LEICA
WITNESS TO A CENTURY

"What is photography?
. . .It is seizing the moment.
It is putting one's head, one's eye,
and one's heart on the same axis."

Henri Cartier-Bresson

ALESSANDRO PASI

LEICA

WITNESS TO A CENTURY

W. W. Norton & Company
New York • London

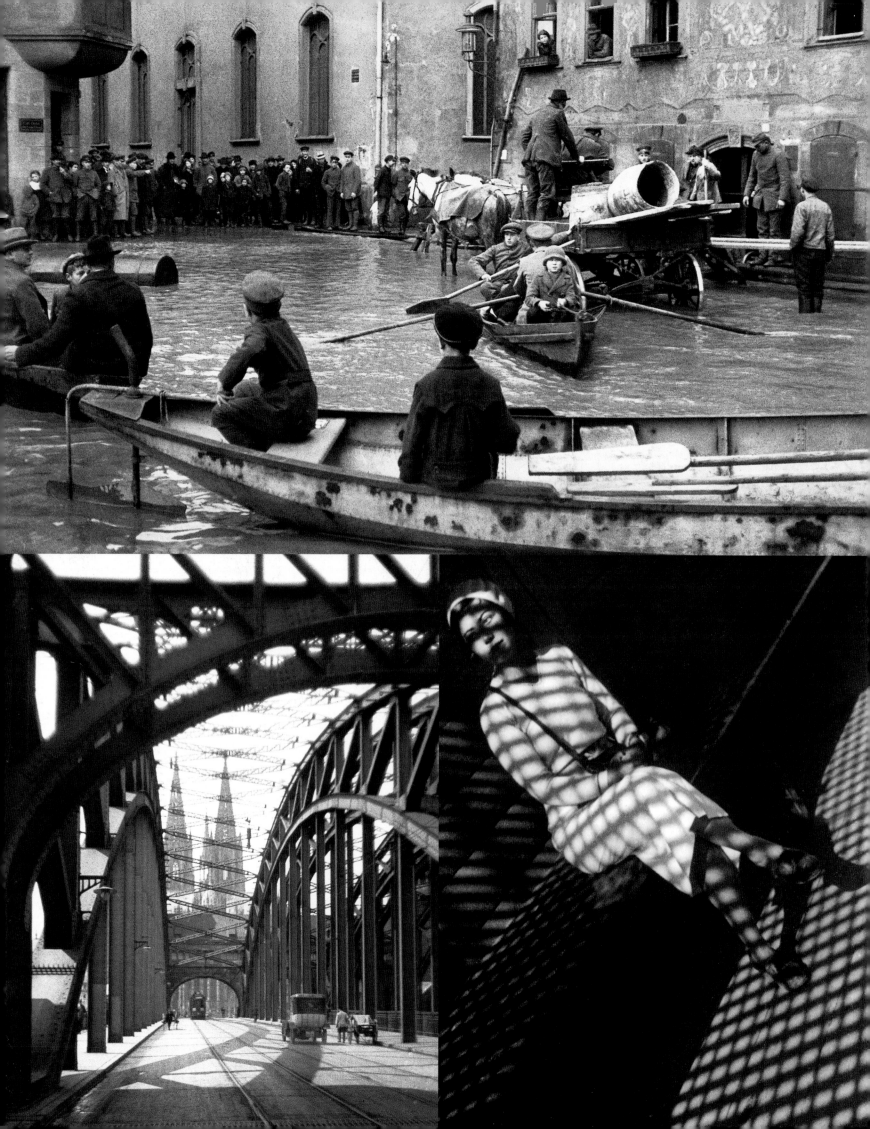

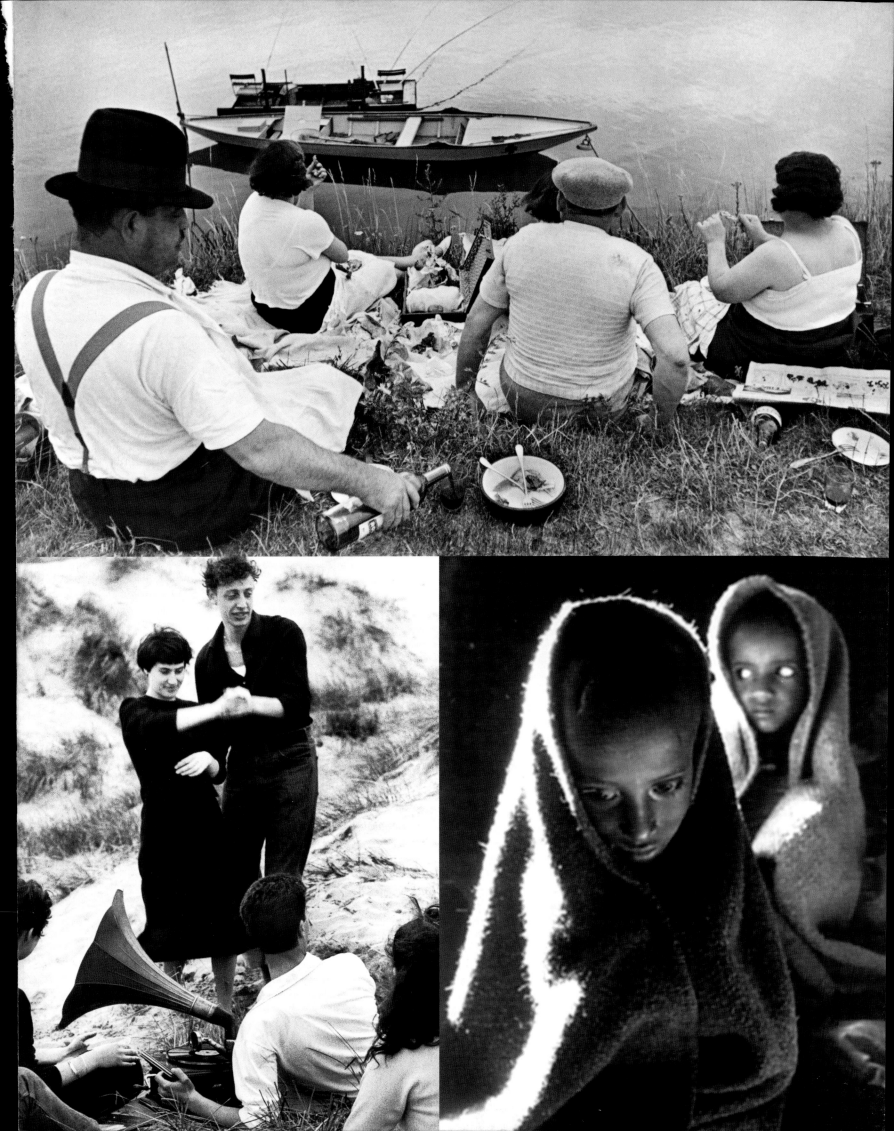

This book would not have been possible without the active
collaboration and assistance of Romolo Rappaini, Leica brand
manager with Polyphoto, the Italian importer of Leica, along with his
wonderful assistant Anna Babic.

For their advice and contributions I would also like to thank Maurizio
Rebuzzini (Leica expert, publisher of *Graphia*, and editor of *Leica
Magazine*); Gianni Berengo Gardin; Luigi Colonna, Leica collector and
historian; Danilo Cecchi, historian of photography and editor of the
monthly *Classic Camera*; and my friends Alberto Battaglini, Roberto
Marchioro, Laura Gnocchi, and Carlo Perelli. Special thanks go to all
the photographers who assisted in the selection of their images:
Piergiorgio Branzi, Mario De Biasi, Luis Cantañeda, Ernesto Fantozzi,
Vanni Calanca, Alberto Bevilacqua, and Claus Bjørn Larsen.

Finally, as is only right, I dedicate this book to my companion,
Alessandra, tireless in her critical assistance and patient in her
support of what by now has become my insane passion for the world
of Leica.

The Author

Leica: Witness to a Century
Alessandro Pasi

Original title: LEICA Testimone di un secolo by Alessandro Pasi
First published in Italy in 2003 by Bolis Edizioni srl, Italy
Copyright © 2003 by Bolis Edizioni srl, Italy
English translation copyright ©2004 by Bolis Edizioni srl, Italy

All rights reserved
Printed in Italy
First English Language Edition

The text of this book is composed in: Novarese Book
With the display set in: Novarese Ultra
Composition by: Michael Shaw
Manufacturing by: Bolis Poligrafiche S.p.A., Italy
English translation by: Jay Hyams

ISBN: 0-393-05921-9

Library of Congress Cataloging-in-Publication Data has been applied
for and will be available on the Library's database at:
http://lcweb.loc.gov

W.W. Norton & Company, 500 Fifth Avenue, New York, NY 10110
www.wwnorton.com

W.W. Norton & Company Ltd., Castle House, 75/76 Wells Street,
London, WIT 3QT

1 2 3 4 5 6 7 8 9 0

This book springs from a conviction that I myself share, although like many such notions it involves a measure of oversimplification: that the history of photography has two beginnings. The first dates to 1826, when a French chemist named Nicéphore Niepce first succeeded in writing on a surface with light, an accomplishment that was heralded as the birth of a new artistic activity. The second dates to 1913, when a German engineer named Oskar Barnack designed and built the first truly portable camera, a camera capable of taking pictures of the world at the same speed at which the world moves—without having it hold a pose.

And, in a revolution within a revolution, the camera used movie film, thus making possible forty-odd images from a single load. And what images they were, for Barnack's camera joined precision mechanics to quality optics. This was the birth of the Leica: "small negatives, large pictures."

All this was the opposite of what had been going on in photography until then, with photographers hauling around big, heavy plates stored in clumsy wooden cases. The arrival of the Leica made it abundantly clear that photography had nothing to do with painting, although it did share painting's ambition to defeat time. But the photo was, is, and always will be something more and also something less than the world it seeks to capture. Leica photographers (including me for the first time, after using many very different cameras) found themselves with a third eye, an instrument of superreliable precision. So the Leica caught on, and at great speed, multiplying the number of enthusiasts, amateurs, and professional photographers.

My long professional experience has taught me that without the Leica, not only my work, but also the entire twentieth century (and also this century), would have had shorter vision.

Looking through a Leica's viewfinder, which always shows you more than the image you're taking, you grasp reality in a more direct, more participatory manner. It may seem hard to accept, but no other camera provides this introspective view. It is no coincidence that this book presents, together for the first time, the histories of how the German camera followed the times and of how the century has been portrayed.

Am I exaggerating? I don't think so. Perhaps, however, I should make this suggestion: pick up a Leica M and hold it up to your eye. Press the shutter release.

The world will seem an extension of your eye.

Gianni Berengo Gardin

Contents

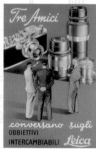

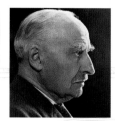

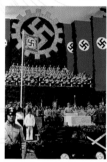
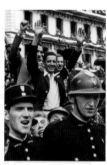

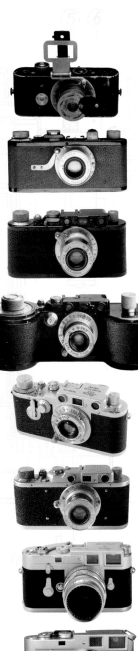
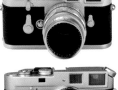

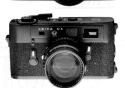
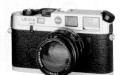
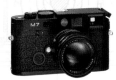
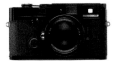

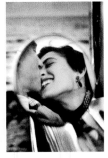
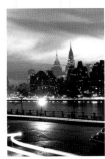
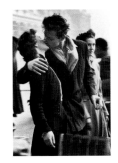

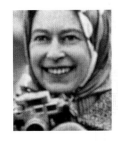
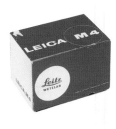
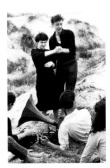

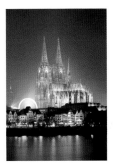

The birth of a star

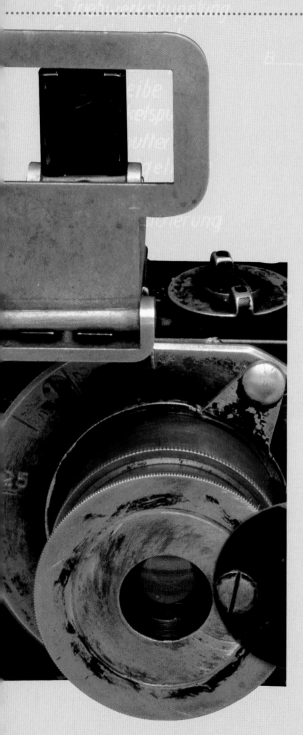

The Thüringer Wald near Wetzlar; the German Empire in the year 1905. A man in a light-colored suit and hat struggles slowly toward the top of a hill. Behind him rises the smokestack of the Optische Werke Ernst Leitz factory. When he reaches the top he opens the tripod of an awkward plate camera with leather bellows. The day is unusually warm, and his asthma is giving him no peace. He takes all eight images on the plates contained in a large leather case. Then he looks at the camera and tries to imagine it smaller—a great deal smaller, and without the tripod. He goes further and imagines it fits in his pocket, and without plates, but loaded instead with film like the kind used in the movies.

And he asks himself: But what would I take photos of?

Oskar Barnack, the next day, asks for a meeting with his boss, the entrepreneur Ernst Leitz, already world famous for microscopes and telescopes. "I have an idea. If we could . . ."
"Go on, let me see."

Thus was born the Leica. And with it a new way of telling the story of the world with images. Without it, the twentieth would have been a truly shortsighted century.

Prehistory: the world in poses

Wetzlar, birthplace of the Leica

Oskar Barnack, the inventor

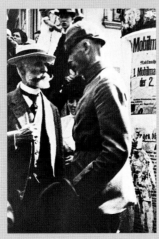

World war delays the Leica

Prehistory: the world in poses
From Niepce to the first portable cameras

The first time

Right, Nicéphore Niepce's home and garden in Grasse, 1826

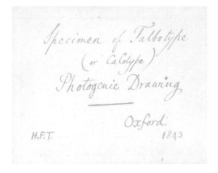

Writing with light

A document of enormous value: the first "writing with light," made by Henry Fox Talbot using a sheet of paper in 1840.

Before the lens

Below, two images from the late nineteenth century: a French soldier and a middle-class Roman.

The history of modern photography, and with it dynamic photojournalism, begins with the Leica. Its arrival made a high-quality portable camera with which to take photographs under all conditions a reality. As such, it represents a true milestone, which is why the long period that runs from the invention of photography to the appearance of the German camera can be referred to as prehistory. To understand the revolutionary significance of the device invented by Oskar Barnack, we must make a rapid review of the preceding ninety years, beginning with the image to the right, which is history's first photograph, taken by Nicéphore Niepce in 1826. The image is hardly clear, but we can make out the shape of a building's sloping roof and part of the garden of Niepce's home in Grasse, in the south of France. Niepce created this photograph by spreading bitumen of Judea over a pewter plate and then exposing it to daylight. Niepce, born in 1765, had been a soldier in Napoleon's army before retiring to private life at his country home, where, together with his brother Claude, he dedicated himself to scientific

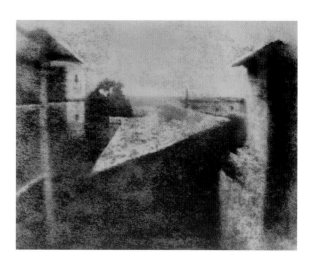

experiments to an effort to achieve what in 1800 was considered the great dream, the ability to represent reality using only light, meaning without canvas and brushes. Throughout the 1700s, painters, beginning with Antonio Canal, better known as Canaletto, had made much use of the camera obscura, a device based on the fact that if a small opening is made in one wall of a darkened room, an upside-down image of external objects (provided they are well illuminated) will appear on the opposite wall. If a mirror is placed on the wall, the image can be projected onto a plate of glass and copied. Niepce was not able to make much progress, however; the images he obtained were weak and required extremely long exposure times. He went into partnership with Louis Daguerre, a painter who specialized in highly realistic theatrical scenery. It was Daguerre who got the all-important idea to abandon bitumen and use instead solutions made with silver salts. Following Niepce's death, in 1833, Daguerre continued with Niepce's son Isidore, and in 1837 he worked out a procedure for fixing an image of the external world to a metal plate. In 1838, thanks to the intervention of Louis Arago, a member of the Academy of Sciences, the two associates gave the rights of their

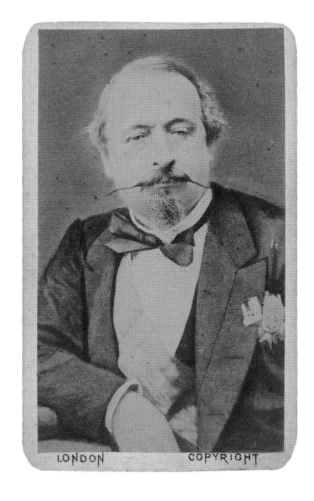

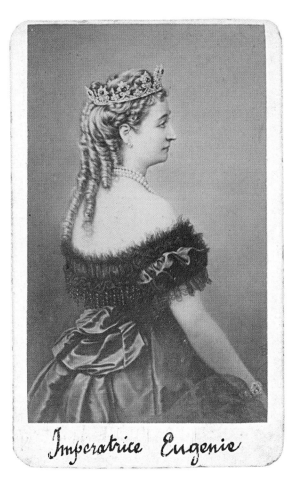

LONDON COPYRIGHT

Imperatrice Eugenie

**The faces
of the powerful**

Left, portraits of Napoleon III
and the Empress Eugenie.
The photos were taken in
London, where Napoleon
went into exile following
France's defeat in the
Franco-Prussian War of 1870.

Wood and brass

Plate camera from the late
nineteenth century.

invention (in exchange for a generous reward) to the French State. Thus it was Arago who, on January 7, 1839, announced to the world the invention of photography, revealing the system used. The "daguerreotype" soon spread throughout the world, while in Great Britain, on January 31, 1839, Henry Fox Talbot announced that he had achieved the same results as the French, but with two important differences. The first was that instead of the metal plates used by Daguerre, Talbot used a sheet of paper as support; the second, that the Englishman's procedure involved two phases, the creation of a "matrix" of the photographic subject and from this the creation of copies. Talbot's procedure went like this: a sheet of paper impregnated with sodium chloride (common salt) was immersed in a solution of silver nitrate, thus forming light-sensitive silver chloride. The sheet was inserted in a camera obscura, already fitted with a primitive lens, and after half an hour the light would have darkened only part of the sheet, that most struck by the solar rays reflected by the subject of the image. The sheet was then rinsed with salt water,

forming a stable image, but in negative. Placing this sheet atop another, also impregnated with silver chloride, obtained a positive image. The world was unanimous in hailing this as the birth of a fifth art and

The long and difficult process of wet-plate photography

Before the invention of film, cameras were large, with heavy wooden bodies and brass lenses, and they used glass plates (the smallest measured 8 x 10 cm); the plates required their own separate container. The process of obtaining a photograph was somewhat complex. Because of the long exposure times (a result of the plate's low sensitivity to light), the camera had to be mounted on a solid tripod; one at a time the plates were inserted in the camera, exposed, and then immediately developed. The first photographers traveled in specially equipped carriages or with portable tents. At the end of the nineteenth century the process went something like this: the light-sensitive solution (the so-called damp collodion) was spread on a plate. The plate was inserted in the camera and the photo was taken, usually requiring ten or more seconds; the image was then developed and "fixed" to the plate, obtaining the so-called negative image, meaning one in which the white and black areas of the subject were reversed. Finally the plate was pressed on a sheet of sensitized paper, which was in turn exposed to light, obtaining the final image.

Group portrait

Above, classical image from the early twentieth century: three generations of a middle-class Italian family

The Kodak revolution

George Eastman with his portable Kodak camera aboard a steamship in 1916.

"You push the button, we do the rest"

An important step toward putting photography within the reach of everyone was the invention of film, in 1887. The main drawback to the wet-plate system was the complicated technical process of preparing the glass plate (the emulsion had to be spread across the plate in the dark and used immediately); there was also the fragility of the plates. Film, made with the new material celluloid, could be prepared in a factory, sold ready to use, and developed later. In 1888, the American George Eastman used the advantages of film to invent the Kodak camera (he also invented the name Kodak, which has no meaning but seemed easy to remember and spell). The Kodak was small in size and came already loaded with a roll of film to take 100 images 6 centimeters in diameter. When the roll was finished the camera had to be returned to the special Kodak shop, which developed the film and returned the reloaded camera. Hence the Kodak slogan: "You push the button, we do the rest."

declaring that painting was dead. Such was not the case, of course. Photography was a new art, a different and more rapid means of representing the world. The nascent middle class made it the witness of its social climb, attributing to photographic portraiture the same value that the aristocracy of preceding centuries had given oil paintings. The primary limitation of the early photographic procedures was the length of exposure time required: the subject had to stay still a long time, so photographers' studios were equipped with a variety of structures to enable men and women to hold their poses. To make the images more artistic, photographers prepared backgrounds with bucolic views or used drapery, columns, statues, or vases of flowers. Among the first to see the representational potential of photography was Gaspard Felix Tournachon, known as Nadar. Over a period of nearly half a century, beginning in 1852, musicians and poets, politicians and members of the middle class posed before Nadar's lens in his Parisian studio, all of them eager to preserve for posterity their "true" image.

Efforts were made to make photography faster. In 1851, the "wet-plate" system using collodion was discovered by the London sculptor and photographer Frederick Scott-Archer. This involved spreading damp collodion on a glass plate and exposing it while still damp; doing so reduced exposure times to

Studio portrait

Left, the children of the well-to-do were immortalized, often with a shadow effect that was quite popular in the early twentieth century.

Sailor's suit

Below, typical vacation "snapshot" from 1910, when a stay by the sea was a social obligation for middle-class families.

tens of seconds. The world was finally just a click away; using carriages or portable tents in which to prepare the plates, photographers could operate in the open, creating images of wars or never-before-seen landscapes or distant peoples. Great events, such as the Crimean War (1853–56) and the American Civil War (1861-65), were presented in their most shocking immediacy, without the heroic embellishments of painting. The next step was the "dry-plate" process, with plates sold ready for use. Then, at the end of the 1800s, celluloid film was introduced and thus also the roll film still in use today. Photography was becoming popular.

Wetzlar, birthplace of the Leica

In a little more than fifty years, photography left the studios and hands of professional photographers to make its way into the homes of ordinary people throughout the world. Cameras were still cumbersome devices, however, and not at all versatile. Even the revolutionary Kodak had that insurmountable drawback of having to be loaded and unloaded at the factory. All over the world, efforts were being made to permit ordinary people to easily and quickly take pictures. The Leica was to suddenly achieve all those goals: small, portable, and easy to use, it was capable of taking 36 images with small negatives of such high quality that they could create large-size photographs. The name Leica is an acronym combining *Leitz* (the maker) and camera. It was born in the place presented on these pages, Wetzlar, a small city in Germany between Frankfurt and Cologne, capital of the Lahn-Dill region. There was nothing dramatic to the city's history until 1862, when the railroad arrived in Wetzlar and the city got its first

The emblems of industry

Below, the smokestacks of the Ernst Leitz factory early in the 1900s. Today Leica Camera AG is located a few kilometers away, in the small town of Solms.

Peaceful provincial life

Above, the main street of Wetzlar, the Kränerstrasse, photographed by Oskar Barnack using a Leica in 1914. The city grew up around a Carolingian church consecrated in 897.

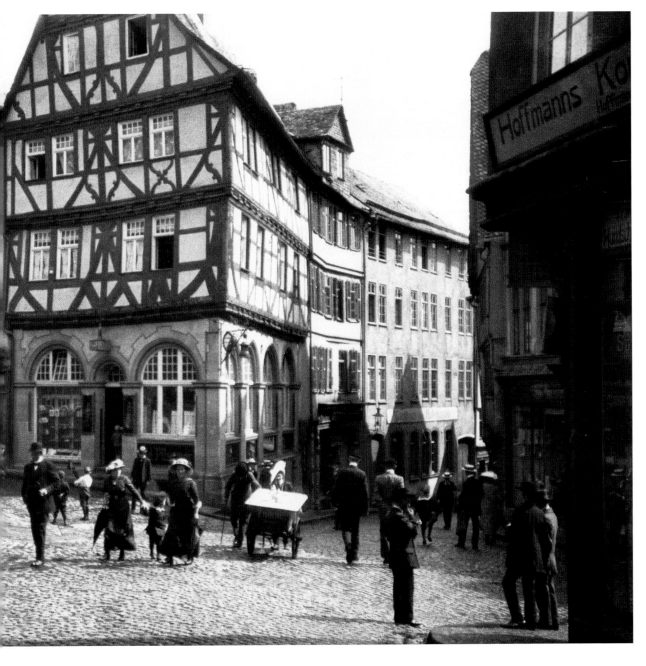

Faithful to itself

Above, three images of Wetzlar today. The town has maintained much of the baroque appearance it had when Barnack immortalized it with the first Leica in 1914.

industries, with factories for the working of glass and steel. In 1869 Leitz was born: the Optische Institut von Ernst Leitz, initially involved in the design and construction of microscopes. Microscopes were in increasing demand, particularly by the scientific community for the study of bacteria, and Ernst Leitz set himself two goals: to make technical improvements to the microscope and to industrialize production. In 1887, Leitz produced 10,000 microscopes; by 1899 that number had grown to 50,000. In 1885 cameras (large-format) appeared on the Leitz list for the first time. That field was directed by Ernst Leitz's sons, Ludwig (1867–1899) and Ernst II (1871–1956). They began to diversify the products, including both cameras and projectors.

Leitz: quality as the objective

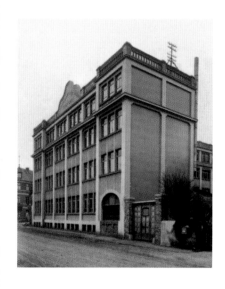

An example of modernity

Above, the headquarters of the Leitz Optische Institut early in the 1900s.

Photography would have remained a completely secondary field to Leitz had it not been for the decisive contributions of two young men who entered the factory in the period 1910–11. The first was Emil Mechau, an engineer who arrived from what was then considered to be the temple of optics, Carl Zeiss in Jena; the second, who came on the invitation of Mechau, was Oskar Barnack, also a former employee of Carl Zeiss. Born in Brandenburg, near Berlin, Barnack (1879–1936) initially refused the job for health reasons, then agreed to a week-long trial and was immediately hired. Ernst Leitz II found him a home at 22 Bruhlstrasse, and Barnack moved to Wetzlar with his wife, Emma, and their two children, Hannah and Conrad. Within a year Barnack had

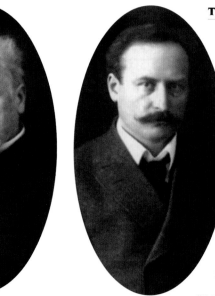

The founders

Left, the founder of Leitz, Ernst Leitz I, and his son Ernst Leitz II. The two pictures were taken on New Year's Day, 1911.

become director of research and development of microscopes. His true passion, however, was photography, which he practiced using the tools of the time, meaning a cumbersome Nettel camera with 13 x 18 mm format plates. Barnack had breathing problems (asthma), and the sheer weight of the apparatus gave him difficulties. He decided to make it lighter. Since he couldn't change the camera, he sought to reduce to a minimum the number of plates he had to haul around by putting several images on the same plate. These efforts proved frustrating; when reduced on the photographic plate the quality of the images was mediocre, with excessive graininess, and the final result was decidedly poor. Just then, however, Barnack's attention was drawn to movie film. Emil Mechau was working on improving the performance of movie projectors. In particular, he was trying to solve the major problem to plague those early projectors, the annoying (and apparently inevitable) fluttering of the images projected on the screen. Barnack was given the task of improving the movie camera itself, which, like other cameras of that time, was made of wood, was cumbersome, and was less than reliable.

The house where Barnack was born: a recently discovered painting shows how it was

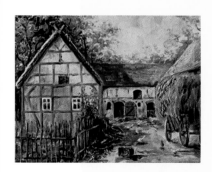

With its pitched roofs, walls supported by crossed poles, and small windows, the farm is a classic of northern European, especially German, building. The image reproduced here is a true rarity, the only known picture of the house where Oskar Barnack was born, which today no longer exists. The painting dates to 1931 and was made by Karl Alexander, a friend of the family; an American collector bought it from Barnack's son Conrad. Then nothing was known of it until 1982, when it showed up at an auction along with other Leica material and was bought by its current owner, an English collector.

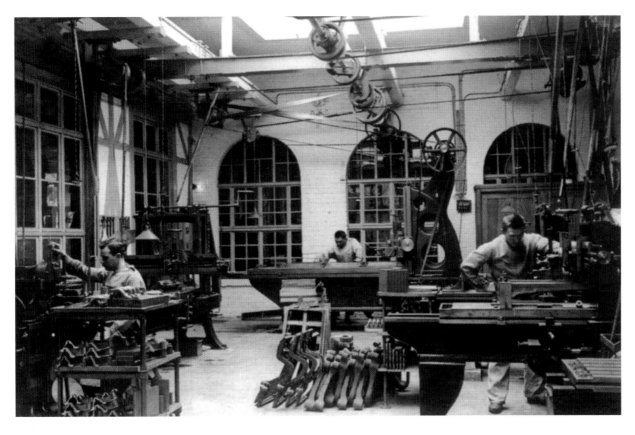

The human scale

Left and below, phases in the creation of lenses and cameras at Leitz in the early 1900s. The production mixed industrial procedures with artisan skills. New employees took training classes and were always held responsible for the quality of the final product.

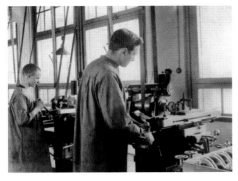

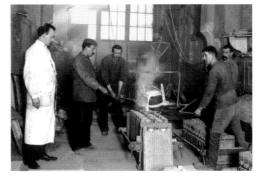

A major problem with all movie cameras was that the film came loose inside the camera and got cut up, causing a great waste of material. Barnack designed and built a camera made entirely of metal, with a mechanism of revolutionary simplicity, a geared drive with chains that ran to two sprocket drums that guaranteed that, with every two full turns of the winding handle, sixteen frames per second passed in front of the gate. Two long bars and the sprocket arms guided the film and held it in place, preventing any lateral movement. The film magazine had a central division forming two lightproof spool compartments. An external aperture was used to frame the subject. Something was still missing, however: a reliable exposure meter. It was while working to solve this problem that Barnack arrived at the most revolutionary camera ever made.

Research in optics, the basis of marvelous photography

One of the pillars of Leica's quality has always been the exceptional quality of its lenses. Left, a central moment in the working of glass: in a platinum melting pot heated to 1200 degrees, a technician (the photo is from the 1980s, but the technique dates back to the founding of Leitz) oversees the progress of the melting of a new type of glass to determine its melting point. The optics department of Leica has more than 40,000 different glass formulas.

Oskar Barnack and Max Berek: the diabolical pair

As we have seen, the hundreds of avid amateur photographers roaming the world armed with tripods and silver plates included Oskar Barnack. Passionate about nature and music, Barnack was a fine chess player and a true pioneer of photography. He dreamed of a camera that would be smaller than the bulky plate cameras of the era but without giving up on the quality of the photographic result. He decided to build the camera himself, and in so doing he overturned the leading theories of photographic images. In fact, early in the twentieth century it was taken for granted that good photographs had to be large, and that in order for them to be large - and of a quality satisfying to the human eye - a large plate had to be exposed, since the more an image was enlarged the more it lost in quality. Barnack

Daughter of a new century

"I believe that there were two main factors that hastened the advent of modern photography. The first of these was a decided change of the times that followed immediately after the war. Modern art had come into its own, modern architecture was announcing a new shell for the new life as different as the skyscraper was from the classical Gothic cathedral. . . . Radio replaced the old phonograph . . . and as for women: the hand that rocked the cradle now steers the car and the old modest blush now became frank rouge with lips that smoked a cigarette on the street. . . . The other factor was a piece of engineering. A small camera was introduced to the world in the year 1925. To many of the old photographers it looked like a toy designed for a lady's handbag. But on closer examination it bore all the evidence of a keen precision instrument designed and manufactured by the ablest technicians of a world-famous microscope company. . . . this camera [was] an instrument of modern expression that dealt the final blow to the old 'imitation art' school of photography. This camera was the Leica!" (Manuel Komroff in *The Leica Manual*, by Williard D. Morgan and Henry M. Lester, Morgan & Lester Publishers, New York, 1938)

saw things the other way: good, large images could be made beginning with even a small-

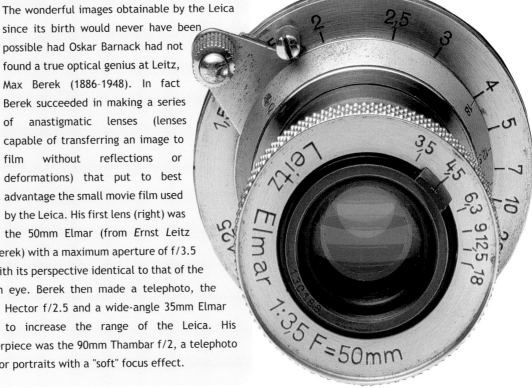

size negative, the important thing being the amount of well-defined information recorded on the negative. Following complex calculations on the perceptive powers of the human eye, Barnack arrived at the conclusion that 1 million elements were required to make an image with sufficient richness of detail. Using optics with a focal length of 50 mm, the nearest to the normal view angle of the human eye, and factoring in the resolving power, 1 million points form a surface of 700 mm². By doubling the frame size of the standard motion-picture film Barnack arrived at the 24 x 36 mm format, with a surface area of 726 mm². Exactly what he needed.

So it was that Barnack decided to use movie film. He then needed to construct a body around this film, a machine to take photographs one at a time. A machine that was sturdy and precise—like a scientific instrument. Barnack proposed his project to Ernst Leitz, eventually calling it Leica. In 1913 he made two examples of the new camera, today known as the Ur-Leica (Ur being German for "original"; Urbild means "prototype").

Max Berek, designer of the optics

Clear ideas

Top right, the original technical design in 3:1 scale of the first Leica, dated September 12, 1927. Right, the standard lens of the Leica, the Elmar 50mm f/3.5, of exemplary clarity.

The wonderful images obtainable by the Leica since its birth would never have been possible had Oskar Barnack had not found a true optical genius at Leitz, Max Berek (1886-1948). In fact Berek succeeded in making a series of anastigmatic lenses (lenses capable of transferring an image to film without reflections or deformations) that put to best advantage the small movie film used by the Leica. His first lens (right) was the 50mm Elmar (from *Ernst Leitz Max Berek*) with a maximum aperture of f/3.5 and with its perspective identical to that of the human eye. Berek then made a telephoto, the 73mm Hector f/2.5 and a wide-angle 35mm Elmar f/3.5 to increase the range of the Leica. His masterpiece was the 90mm Thambar f/2, a telephoto lens for portraits with a "soft" focus effect.

21

Ur-Leica
The revolution was already in this awkward device

Here is the prototype of the Leica, known as the Ur-Leica, made in 1913–14. Its principal characteristics: an all-metal body, collapsible lens (folding into the body to reduce bulk when the camera was not in use), frame counter (up to 50, later reduced to 36 for practical needs), strap lugs, shutter that was set with the advance of the film to avoid double exposures, and a lens cap to avoid fogging the film during shutter rewind. Lightproof film canisters had not yet been invented, so the camera had to be loaded in the dark. Over the course of the years, the Leitz company produced several hundred copies of the Ur-Leica, assembled as training assignments by the apprentices in the Leitz technical school and today highly prized by collectors.

Camera body

The Leica was built in a single piece, probably using a section of tubing from the dirigible industry. The walls were 2.5 mm thick, the camera was 28 mm wide, 128 mm long, and 52 mm high. The top plate was cast, the baseplate was attached with a screw.

Film advance

The knurled knob advanced the film while at the same time setting the shutter, an arrangement that avoided double exposures. The shutter release is at the center.

Viewfinder

The prototype had a rudimentary sighting system composed of a plate with an aperture and a frame, matching the field of view of a 50mm lens, the nearest in perspective to the human eye.

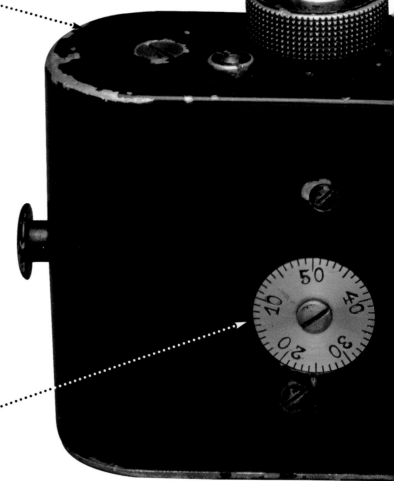

Technical data

Years of production:	1913-1914
Serial numbers:	none
Quantity made:	three
Finish:	black
Lens:	fixed
Shutter:	focal plane, not overlapping
Viewfinder:	absent
Rangefinder:	absent
Self-timer:	no
Strap lugs:	yes

Note: The first example was built in 1913, and another two prototypes, with slight modifications similar to the first series models, were built in 1914. The first experiments were done using a Kino Tessar lens (for movie cameras) followed by a 50mm Anastigmat f/3.5 lens, designed by Max Berek.

Frame counter

Located on the front of the camera, the counter (up to 50 frames) automatically advanced one notch with every complete turn of the film-advance knob.

World war delays the Leica

On August 2, 1914, Oskar Barnack took this image with the Ur-Leica: a soldier has just affixed to a column Emperor William II's order for total mobilization. The Austro-Hungarian Empire was about to declare war on Serbia, accused of having instigated the assassination of Archduke Francis Ferdinand in Sarajevo by Gavrilo Princip, member of a Serbian nationalist organization. World War I was about to begin, and Barnack was forced to temporarily shelve his ideas for beginning production of his small camera. That camera, visibly improved, would be presented to the public a decade later, at the Leipzig fair of 1925.

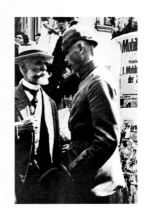

Shutter speed

Turning this dial regulated the speed of the shutter (a focal-plane shutter but with a fixed width adjusted by a spring); there were two speeds: 1/25 and 1/50 of a second.

Lugs for the shoulder strap

Unlike the first production model, the Leica prototype had lugs for a leather shoulder strap; these reappeared with the Leica III.

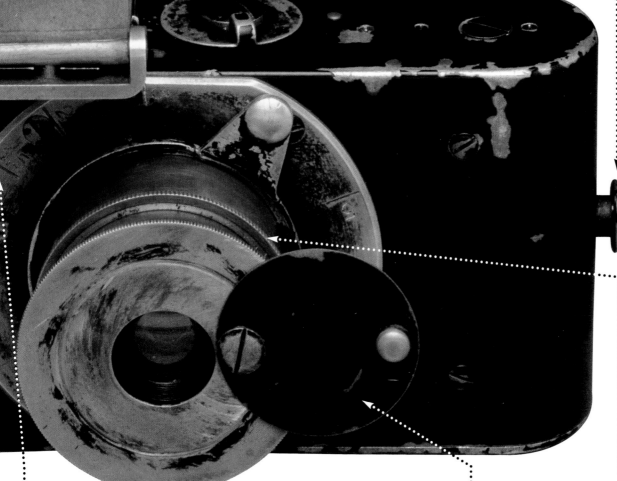

Brass lens

The lens of the Leica was collapsible so that the lens could be folded into the body of the camera to reduce bulk. This prototype, preserved in the Leica museum, has a 42mm Leitz Milar, but it initially had a Kino Tessar.

Focusing lever

A convenient lever turned the lens for rapid focusing. The distance of the subject had to be estimated by eye.

Lens cap

The lens cap covered the lens after taking a picture to prevent light from entering during shutter rewind.

Leica is ready
and goes into the street

Ernst Leitz II tried out the Ur-Leica during a short trip to the United States and was pleased with it and enthusiastic about its prospects. Even so, production of the camera did not begin immediately; in fact, the plans for a Leitz camera stayed at the design stage for another ten years. Barnack himself immortalized the reason for the delay, early in August 1914. Walking through the streets of Wetzlar he took an unusual picture: a soldier of the Reich with the classical spiked helmet affixing the proclamation of Germany's total mobilization to a column. Europe was catching fire, on the brink of four years of war, the first to involve the world.

In an article published in a local newspaper during the 1930s Barnack described the birth of the camera and its original characteristics. "How did I come to make the Leica? I must look back two and a half decades, more or less back to 1905. Back then I took pictures using a camera that took 13 x 18 plates, with six double plate-holders and a large leather case similar to a salesman's sample case. This was a quite a load to haul around when I set off each Sunday through the Thüringer Wald. While I struggled up the hillsides (bearing in mind that I suffer from asthma) an idea came to me. Couldn't this be done differently? . . . Meanwhile my work had changed for I had joined the Optische Werke Ernst Leitz. There, among my other activities, I became involved in techniques of cinematographic recording, and I soon was drawn to the right way by the fine grain of the cine film. An enlargement from the cine format to the size of a postcard could already be undertaken, but in the meantime I had become more demanding. Postcards, most of all those of the 6 x 9 mm format, make nice souvenir

Two men, one idea

Above, seated on a bench in Wetzlar in 1920 are Ernst Leitz (left) and Oskar Barnack. The decision to put the Leica into production was in part a result of the German businessman's respect for Barnack's abilities.

A thankless profession

Late nineteenth-century French cartoon in which the Sun smiles down on a photographer struggling along with his weighty photographic equipment piled on his back.

photos, but the true photo begins only at 13 x 18 or, even better, at 18 x 24 . . . it is true that the larger the photo the more three-dimensional and realistic it becomes. Thus the frames of motion-picture film were too small. Thanks to the magnificent invention of standardization, the movie film could not be made wider, so in order to get the most out of it I had to enlarge the format as far as possible. I immediately went to double width, and in fact it worked quite well, 24 mm of width and 36 of length. Thus was born the Leica format. I still believe that the 2:3 ratio is the

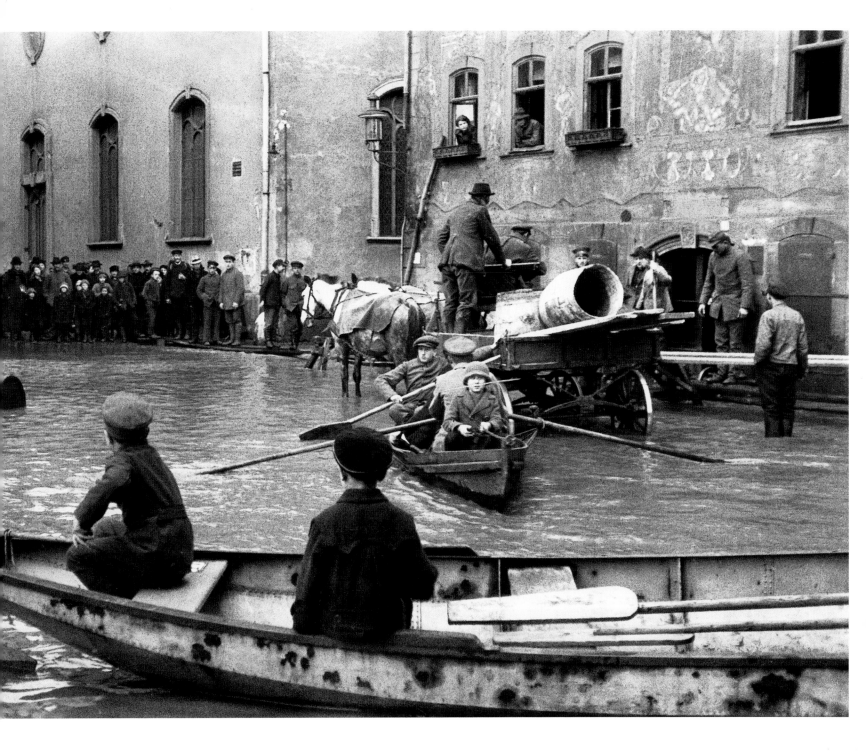

best and most practical. Now began the true construction of the Leica."

When the Great War had ended and the depression that followed it had been overcome, Leitz returned to the Leica project. In order to get a response from the public and from photographers Barnack built several pre-series cameras, the Leica O-Series, or Null-Series. Thirty of these were made, with numbers running from 100 to 130, divided in two groups. The first group, very similar to the Ur-Leica, went to production number 121. The second group of another ten O-Series went up to number 130; these already had a shutter that closed on its own (goodbye to the awkward lens cap) and shutter speeds from 1/20 second to 1/500 second. The lens was a 50mm Leitz Anastigmat five-element lens designed by one of the most skilled of Barnack's collaborators, a man whose name soon would be associated with the success of the small German camera: Max Berek. Seventeen of these 0-Series Leicas have survived, but only No. 104 is in the Leica museum.

Flood in Wetzlar

Above, a picture of the flood that struck Wetzlar in 1920. The flood offered Barnack the opportunity to demonstrate the journalistic promise of the small Leica.

Leica I

Presented at the Leipzig fair in 1925, the Leica I had numerous technical improvements over to the prototype, and it attracted immediate approval. The most important improvements were the built-in optical viewfinder; the self-capping variable-slit focal-plane shutter (with a large choice of shutter speeds), which eliminated the danger of light infiltration during rewind; a frame counter at the base of the film-advance knob; an accessory shoe; and a diaphragm ring on the lens with a maximum aperture of 3.5 and then

Leica I Luxus (1929), with gold plating and lizard skin.

even 2.5, a true record for that period. The lens was still collapsible to reduce bulk, although it was necessary to remember to pull it out before taking a picture. The camera was very compact and exceptionally sturdy. Five years later, again at the Leipzig fair, a model was introduced with interchangeable lenses, a wide-angle 35mm and a 135mm telephoto, both from Elmar, which increased the camera's versatility.

Film advance

This knurled knob served to set the shutter and advance the film. At its base was the frame counter.

Shutter-release button

This was one of the outstanding elements of the Leica: easy to use, the mushroom button that released the shutter was famously quiet.

Shutter speed

The shutter speed was set using a scale of speeds expressed in fractions of a second, from 1/20 to 1/500. The setting Z allowed for slower speeds.

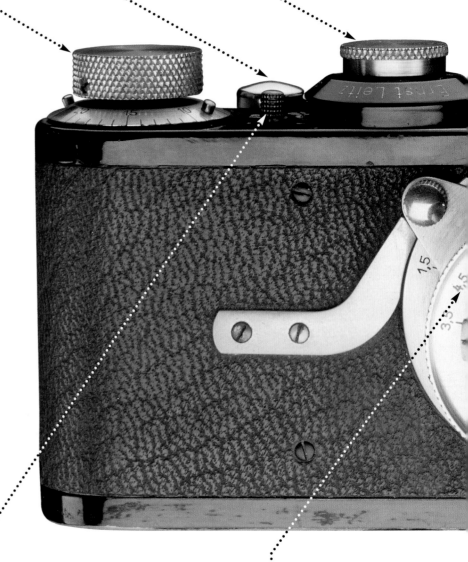

Reversing knob

The small knob disengaged the film from the advance system so it could be rewound into the left spool.

Diaphragm ring

On the front of the lens was a scale with the aperture settings, selected using a metal lever.

Accessory shoe

From the beginning the Leica had an accessory shoe for the attachment of a flash or an external rangefinder for precision focusing.

Viewfinder

The direct vision optical viewfinder "reproduced" the angle of vision of the standard 50mm lens.

Rewind knob

With this knurled knob the film was rewound after taking the 36 shots provided by the Leitz rolls.

Leitz poster for the Leipzig fair. Leica's motto was "Small negatives, large pictures."

Focusing mount

The lens was focused by being turned in or out; the mount bears the measurements (in meters) of the focal distance of the subject.

Technical data

Rarity grade:	● ● ●
Years of production:	1925-1932
Serial numbers:	131 to 71,249
Quantity produced:	58,919
Finish:	black
Lens:	fixed
Shutter: :	focal plane
Viewfinder:	direct vision
Rangefinder:	no
Self-timer:	no
Strap lugs:	no

Note: The Leica I came with the Anastigmat 3.5/50 (200 units), the Elmax 3.5/50 (800 units), and the Elmar 3.5/50. In 1930-31 the Hector 2.5/50 was mounted on 1,330 cameras.

Oskar's winning idea:
"Small negatives, large pictures"

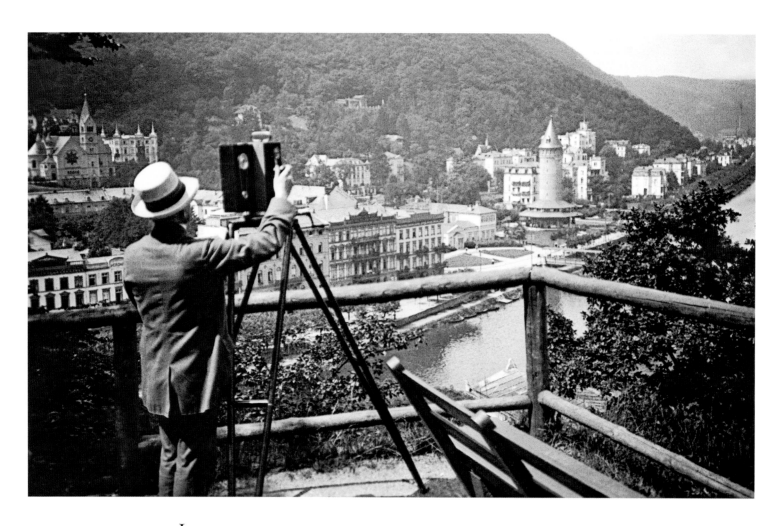

Behind the camera

Above, Oskar Barnack in a photo taken with a Leica while operating a 35mm Leitz movie camera that he himself had designed.

In response to the enthusiasm of professional photographers and the public, the Leica was officially presented in 1925.

Ernst Leitz II's decision to go ahead with the camera was a mixture of courage and desperation. Leitz not was known as a camera manufacturer and did not enjoy a great reputation in the field; Leitz's first plate cameras had, in fact, received a somewhat cool reception. The German market was dominated by Zeiss, along with a series of companies that have since disappeared but that at the time enjoyed popularity among photographers, such as Ernemann, Contessa-Nettel, Voigtländer, Franke & Heidecke, and Ihagee. Furthermore the first cameras to use movie

film were appearing, although no manufacturer had yet arrived at the 24 x 36 format. What is more, all of them permitted the exposure of hundreds of pictures, as many as 750 in the case of the American Herbert & Huesgen. They were exceedingly awkward, but their greatest drawback was that the small size of the negative did not permit enlargements of acceptable quality.

A final factor to consider is the stagnation of Germany's economy. By moving into what was, despite the drawbacks, considered a commercially promising sector—photography—Leitz escaped the dangers of seeing its earnings collapse. In the end, however, scholars of Leica history agree that the

decisive factor was psychological and was based on the excellent relationship, full of faith and mutual respect, between Ernst Leitz and Oskar Barnack. In 1924 the production of the Leica I began, and the following year the model was ready to face the market, under the name of Leitz. But before the camera was put on sale, the German businessman realized the importance of giving a new name to his camera. Several names were considered and discarded before arriving at Leica. Barnack Camera, for example, was discarded because Barnack did not yet enjoy enough prestige among photographers for his name to guarantee the quality of the product; Lilliput, the name originally proposed by Barnack himself, had to be discarded because it had already been registered by a competitor, Ernemann; Leca, which united the first two letters of Leitz and camera, had to be abandoned because although short it did not sound good and there was the risk of its being confused with an already existing camera, the Eka. The addition of the *i* gave the name a pleasant and easy sound.

When the camera was revealed at the Leipzig

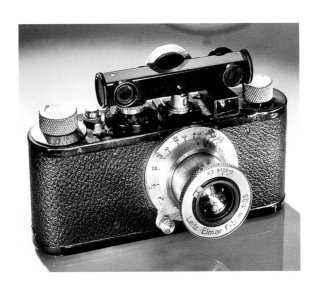

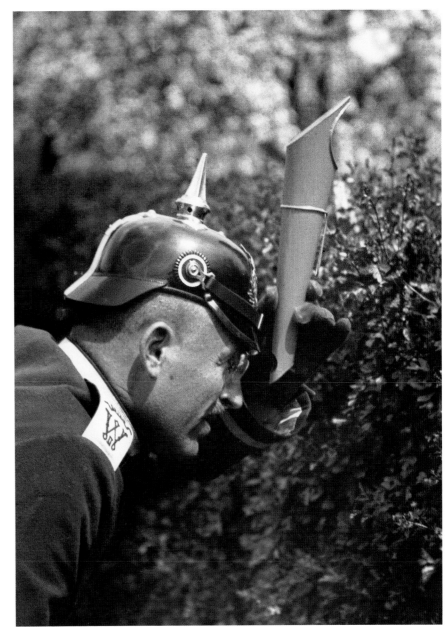

fair it received a warmer reception than anticipated, although some of the responses emphasized the uncertain future of this further attempt to make a small-format camera. Among those that distinguished themselves for short-sighted views was an Italian magazine, the authoritative *Corriere Fotografico*. Its reporter paid scant attention to the presentation of the Leica, dedicating four lines of text to it, including several descriptive errors. In fact, the *Corriere Fotografico* spent columns of text extolling cameras and devices that have long since passed out of memory and lamented the fact that, despite all the variations on the theme of the small-format camera, any true novelty "that might indicate a new way, that

The winds of war

Above, German army officer making use of an early periscope; this is one of the first photographs taken by Barnack using the Ur-Leica.

The first rangefinder

Left, a Leica with what was at the time the most important accessory, first put on sale in 1924: a rangefinder for the precise measurement, using a small wheel, of focusing distance.

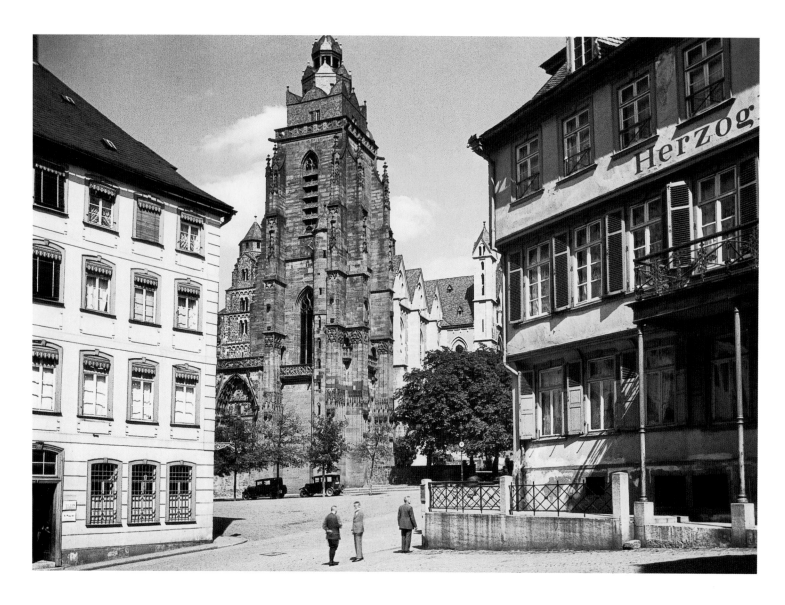

The cathedral of Wetzlar

The cathedral of Wetzlar, made of red sandstone, with its façade visibly unfinished: Oskar Barnack took this picture of it in 1924.

responded to the demands that have been felt for so long, was completely missing."

Near the end of its report of the Leipzig fair the *Corriere Fotografico* dismissed the Leica with these lines, notable for their lack of farsightedness: "We also recall the Leica camera from Leitz of Wetzlar, which gives forty [*sic*] images of 36 x 48 mm [double *sic*] on a length of movie film; releasing the shutter automatically advances the film." Even so, as has already been said, Leica met with greater success than had been expected. In 1926 all of the 1,500 Leicas built were

sold. In 1930, with the introduction of the Leica I Model C, with the 39 x 1 mm threaded lens mount for interchangeable lenses, the number of buyers grew to 19,895. There were four available lenses: a 50mm, the Elmar f/3.5, the wide-angle 35mm Elmar f/3.5, a small telephoto lens, the 75mm Hektor f/2.5, and a long-focus telephoto 135mm Elmar f/4.5.

We've already described the reasons behind Leica's success; now we can review them, also bringing to light certain defects in the system, defects that Leitz sought to overcome through the production

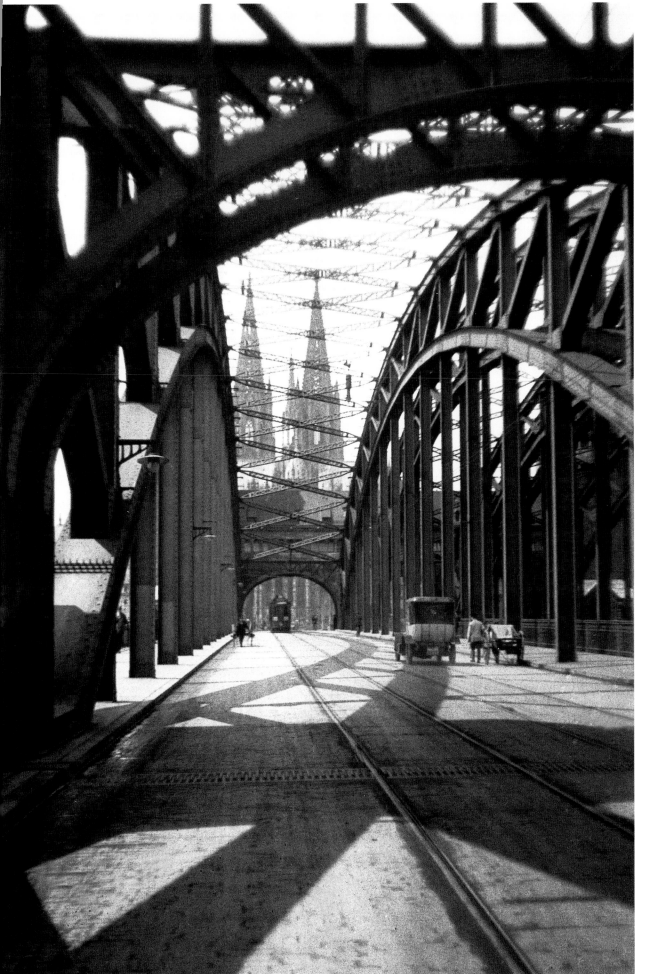

Everything in focus

This image of the bridge of Cologne with that city's cathedral visible in the background was taken by Barnack and testifies to the depth of field of the early Leica lenses.

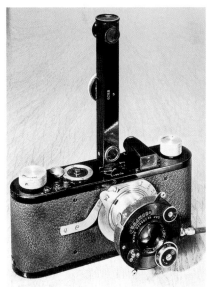

Object of desire

Above, the Leica Compur, named for the Compur leaf shutter mounted between the lens elements, produced in 1926. It was designed to be a simpler and less costly camera than the Leica I. It did not meet with much success, and only 1,607 examples were produced. Today, it ranks among the Leicas most avidly sought by collectors.

The shadow of
the zeppelin

Right, in 1913 Barnack took
photos using the Ur-Leica from
a zeppelin dirigible. The
symmetrical composition of
the image reflects a taste
typical of the period.

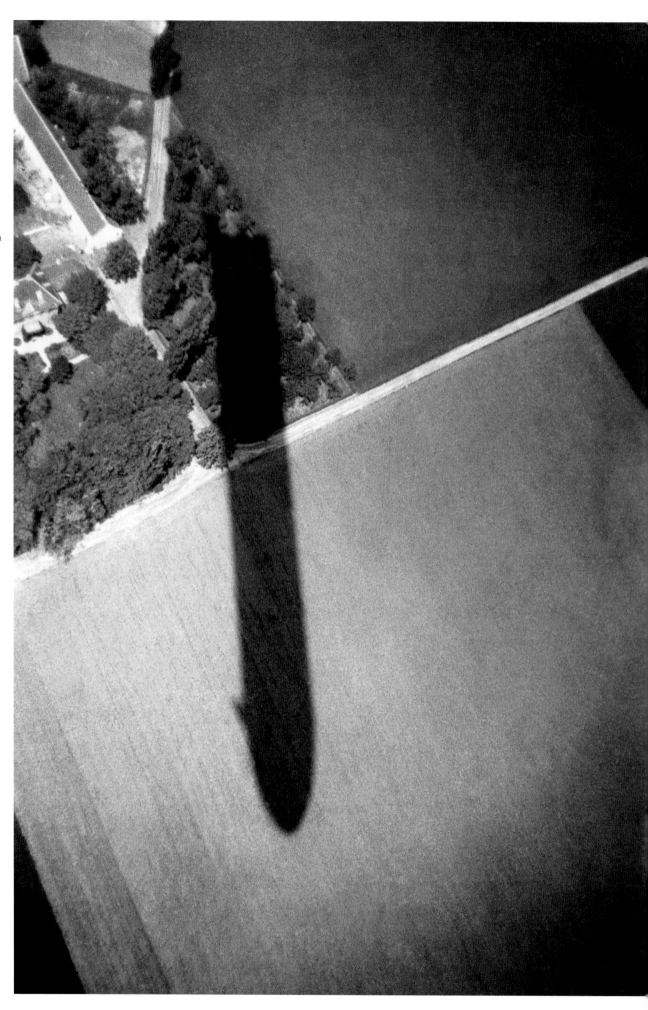

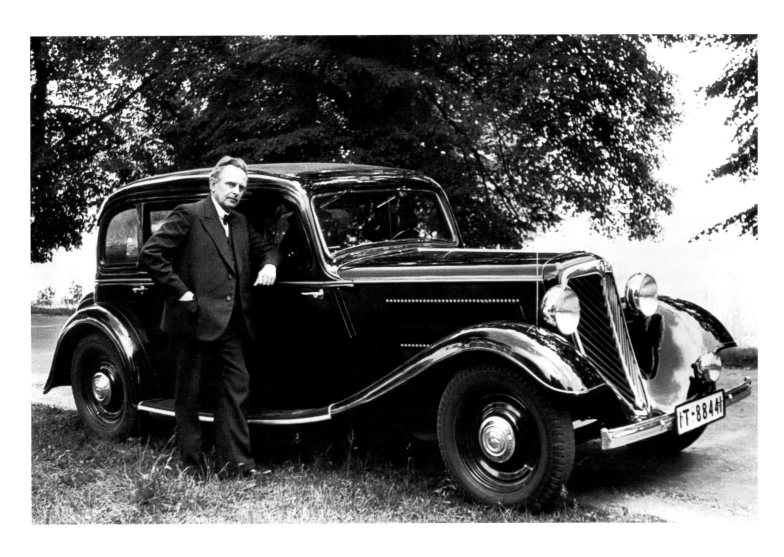

of various accessories.

The first reason of success can be explained by the ease with which the Leica could be handled and used. The second was the camera's strength and dependability (still valued today) and the convenience of having the shutter setting coupled to the film advance, which avoided the widespread problem of double exposures. The dependability was guaranteed by the scrupulous quality controls that Barnack—himself a demanding technician—imposed on Leitz. Only the best quality materials were used in the construction of Leicas, and the workers who assembled the cameras received

thorough training. The climate throughout the factory was one of cooperative teamwork, and original ideas were highly valued. The arrival of the Leica II in 1932 with its built-in coupled rangefinder and its interchangeable lenses provided the final impulse, earning Barnack's camera a position of high regard among professional photographers.

As for the defects, the principal defects were the viewfinder, which remained small even in larger Leicas, and the rangefinder's inability to handle telephoto lenses over 135 mm.

A successful man

Above, Oskar Barnack posing with a new car in the 1930s, at the height of the success of "his" Leica.

The society debut

The appearance of the Leica revolutionized the way of portraying life, accelerating the speed of seeing the surrounding world and fixing it to film. Among the first to become aware of the enormous potentials of the new camera was a German photographer, today recently rediscovered, Paul Wolff. His large-format (30 x 40 cm) prints and his photography books with surprising color images fascinated the public and made an important contribution to the consolidation of Leica's success. The crisp, almost geometrical style of his images met with great favor in Europe, and most of all in Germany, for people found in his images the serenity that the difficult years following World War I had canceled. But the Leica was a true world citizen, easily making its way across all borders. During those same years it showed up in flight aboard zeppelin dirigibles, in Moscow in the hands of Rodchenko, and in Paris in those of Kertész and Cartier-Bresson; it appeared in a leading role in the last great peaceful event of the 1930s, the Berlin Olympics, where it was used without political bias by Leni Riefenstahl.

**The forgotten pioneer,
Paul Wolff**

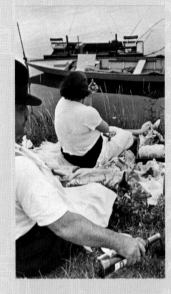

**Henri Cartier-Bresson,
reality taken by surprise**

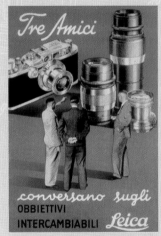

**Leica begins to
publicize itself**

**Leni Riefenstahl,
when art does not see politics**

A pioneer forgotten and rediscovered: Paul Wolff

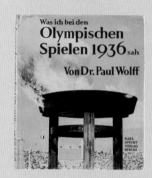

Wolff's output

From top to bottom, books by Paul Wolff: *My First Ten Years with the Leica* (1st and 4th); *What I Saw at the 1936 Olympic Games* (2nd), and *Work!* (3rd).

The rediscovery of simplicity

Paul Wolff, famous over the course of the 1930s as an exciting pioneer of photography with the Leica, met an unmerited fate: oblivion. His death, on April 10, 1951, passed unnoticed. Today, more than fifty years later, he is being rediscovered, and his posthumous fame does justice to one of the most prolific German photographers. In response to the growing interest in his way of seeing reality, the Leica Gallery in New York dedicated an important retrospective show to his work in 2001, including dozens of images. He worked equally well in both black and white and color, making images that were highly stylized and realistic at the same time. The selection of his pictures presented on these pages dates to the period between the end of the 1920s and the beginning of the 1940s. Wolff began taking pictures in 1918, immediately after the end of World War I, using a large-format camera. His skepticism toward the small-format 24 x 36 camera ended when he won a Leica, in 1926; almost by accident he succeeded in overcoming the graininess that afflicted the early prints from small negatives. Through the expedient of overexposing the negatives (exposing them to more light than needed) and then underexposing them in development (reducing the time) he reinforced the contrast between black and white and reduced the graininess of the final print. Wolff assembled his "experiences with the Leica" in a book published in 1934 that came to influence an entire generation of photographers, both professionals and amateurs. It was during that period, beginning in 1933, that the Nazi party came to power in Germany, and Wolff did not hide his high regard for the ideas of greater Germany and Adolf Hitler, although he was never an activist, and nor was he ever a member of the NSDAP (National Socialist German Workers' Party), as indicated by research in the German archives. In truth he found himself in a situation similar to that of another great master of the photographic and

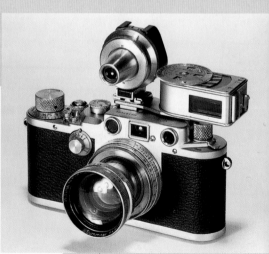

Indispensable accessories: the universal viewfinder and the external light meter

The Leica was a simple camera to operate but had two traits that limited its use, defects that were common to the small-format cameras of that period: the image offered by the viewfinder was limited to the field framed by the standard (50mm) lens, and there was no light meter. Thus, the exposure was done by eye following instructions on how to match the shutter speed with the aperture according to light conditions. In full sunlight, for example, because of the low sensitivity of the film, the diaphragm was set to 5.6 with the shutter speed at 1/100. To avoid these inconveniences, Leitz made the two accessories shown to the right, mounted on the top plate: an adjustable universal viewfinder for other lenses and a manual light meter.

The Skier, 1932.

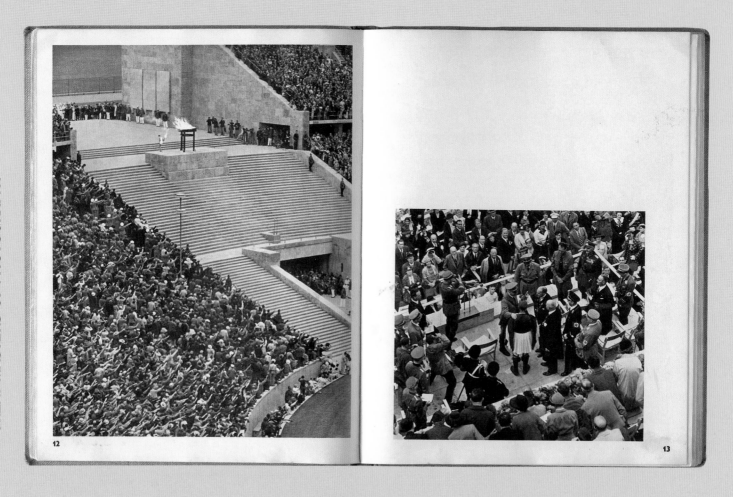

Pages from *Was ich bei den Olympischen Spielen 1936 sah*, (What I Saw at The 1936 Olympic Games), 1936.

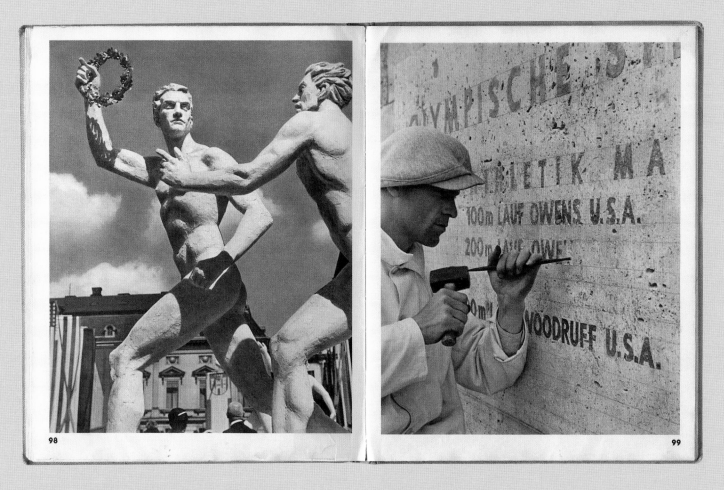

Pages from *Was ich bei den Olympischen Spielen 1936 sah*, (*What I Saw at The 1936 Olympic Games*), 1936.

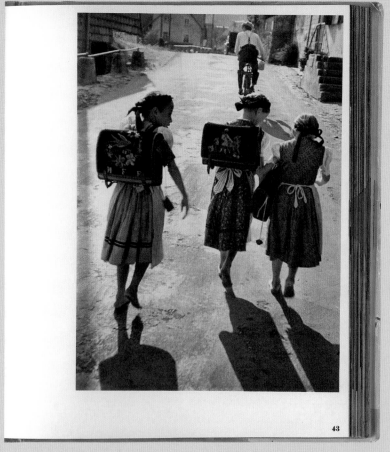

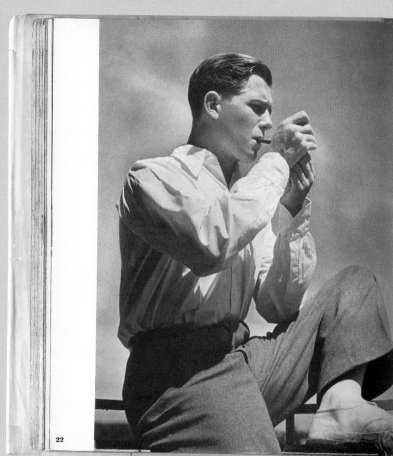

Pages from *Meine Erfahrungen mit dem Leica,* (*My First Ten Years With The Leica*),1934.

cinematic image, Leni Riefenstahl. The new regime offered both of them exciting opportunities to work, and neither Wolff nor Riefenstahl let those opportunities get away. *Meine Erfahrungen mit dem Leica* ("My First Ten Years with the Leica") was followed by other photography books: *Was ich bei den Olympischen Spielen 1936 sah* ("What I Saw at the 1936 Olympic Games") in 1936; *Arbeit!* ("Work!") in 1937; and *Im Kraftfeld von Rüsselsheim* ("In the Rüsselsheim Foundry") in 1940, made using the first Agfa color film. During the war Wolff's home in Frankfurt was destroyed by an Allied bombardment, but all his negatives had been safely stored in the basement of a brewery in the Frankfurt countryside and thus survived the war. Today they are owned by Thomas Sommer, whose father was a close relative of Paul Wolff's associate, Alfred Tritschler. Sommer is the

current curator of the Paul Wolff Archive in Offenburg.

Wolff had begun his business association with Alfred Tritschler before the war, specializing in industrial photography. During the 1950s the studio failed to keep up with changes in taste and the market, and following the death of Wolff—who had never been a photojournalist—Tritschler began to abandon the field, finally withdrawing to life in the woods of Bavaria, in 1968, the year in which the father of Thomas Sommer, who had worked with Tritschler, came into possession of the archive, which contains about half a million images on 35mm film. Wolff's photographs began to be requested for calendars, books, and even by several major German companies, whose growth Wolff had documented for more than a decade. Wolff had

40

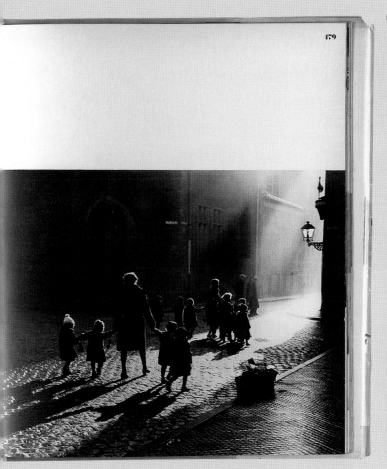

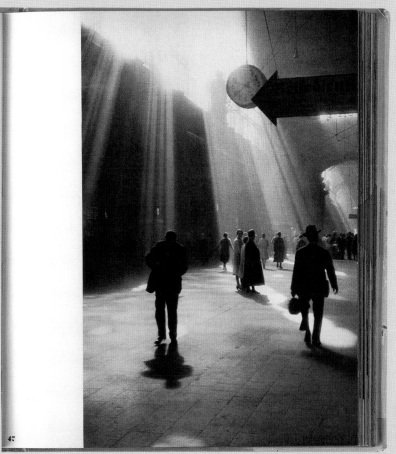

a "pictorial" style, completely appropriate for the dominant taste of the period in which he worked. He never troubled himself with the cruder aspects of reality, seeking instead to exalt whatever he pictured. In his photographs of zeppelins, of reflections on water, of winter days, even of metal pouring from the blast furnaces of steelworks, one always notes an effort to achieve a visual aesthetic in which man is always at the center, never on the side. Wolff made enormous contributions to the fortune of the Leica. His books forcefully demonstrated what could be achieved using the small camera, turning the Leica into a marvelous tool for framing the world. It was no longer necessary to ask reality to put itself in a pose; reality itself almost demanded to be photographed, all that was needed was knowing how

to use a Leica viewfinder. This was the same approach that, in the same period and for a long time after, was used by Henri Cartier-Bresson, one of the greatest photographers of all time. Cartier-Bresson did indeed want to put his "head, eye, and heart" on the same axis when he took a photo. There was one fundamental difference, however, in that Cartier-Bresson's approach to photography was more demanding, requiring as it did the ability to spot what he called "the decisive moment." Such is not the case with all of Wolff's pictures. With the obvious exception of his sports and action photographs, many of his pictures, despite their appearance, were posed. Admirably done, but posed nonetheless.

Erberto Rüedi,
La fotografia e la Leica
Stucchi, 1938

In 300 pages, everything about the camera and how to use it. Below, the Ballets Russes at the Manzoni Theater in Milan, using Agfacolor film.

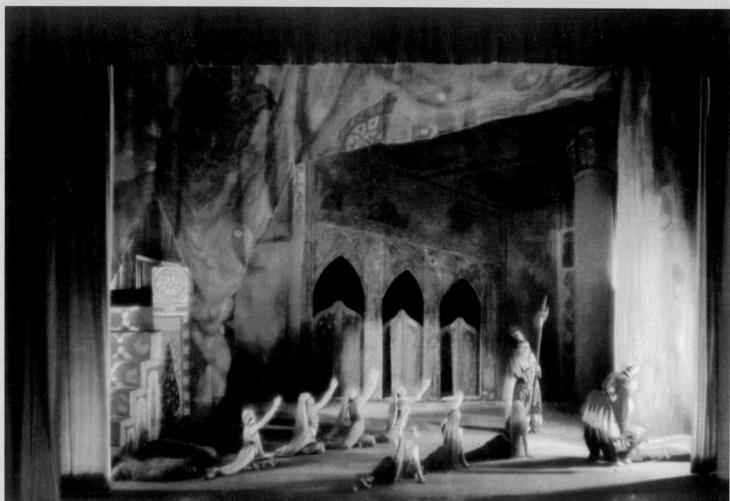

Rüedi, Feininger, Kisselbach, other pioneers of "beautiful images"

The invention of the Leica put quality photography within reach of the vast world of amateurs. To help them to get the most out of the new system, books and manuals of photography proliferated, beginning in the 1930s. These books are highly prized by collectors today. The three authors presented here were quite well known in their time, the Italian-Swiss Erberto Rüedi and the Germans Andreas Feininger and Theo Kisselbach. Their instructional books explain the process of photography in great detail, going over every step from taking the picture to making a print. Today we are used to thinking of the

world in four colors, but it was a great novelty in the 1930s. The first two manufacturers to come out with successful versions of color film were the German Agfa with its Agfacolor film and the American Kodak, with its Kodachrome transparencies, which were of an extremely fine grain. The Leica made it possible take pictures in limited light and without a tripod, the latter an aspect highly valued by photographers in part because the average light sensitivity of the film then available was a quarter of today's, rarely reaching 21 ISO, whereas today's standard is 100 ISO.

Andreas Feininger,
Menschen vor der Kamera,
 W.H. Verlag, 1934.

A very successful manual that deals
with more than just the Leica.
Below, an example of a photo by
candlelight.

Theo Kisselbach, *Il*
Libro della Leica,
Heering Verlag, 1935

The author worked with
Leitz for thirty years.
Below, an example of a
photo in ambient light.

The Leica in the clouds:
someone up there sees us

In addition to being an ingenious inventor and a fine photographer, Oskar Barnack was also a pioneer, and in the true sense of the word: his fascination with the possibilities offered by his camera led him to go into areas no one else had yet thought to explore. Thus he was among the first to climb aboard the zeppelin airships, true giants of the air and the pride of German industry since they represented the most advanced aeronautical technology of the time. From the photographic point of view the zeppelin had a great advantage over an airplane, since it could fly at low altitudes and literally stop in the air at whatever altitude was desired. We have already seen an image that Barnack took from a dirigible, with the shadow of the airship standing out clearly against the countryside, a result of

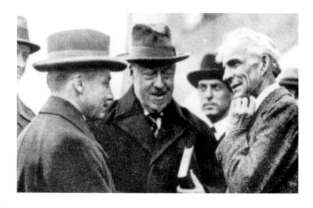

the typical softness of images taken with the Ur-Leica. Early in the 1920s, Barnack made friends with Hugo Eckener, who was first a test pilot and later the commandant of the dirigible LZ 127. This zeppelin made numerous transoceanic voyages, with routes that took it to New York, Recife in Brazil, and Africa, flying over the Mediterranean and Egypt. Eckener's most important undertaking was a trip around the world, from August 15 to September 4, 1929. Barnack gave him a Leica in 1926 and a second was given in homage to Count Ferdinand von Zeppelin. Eckener's Leica, number 280, is now owned by Paul-Henry van Hasbroeck, a leading expert and collector, who acquired it from an American collector, who in turn got it from the grandchildren of Count Zeppelin in exchange for an M series Leica. A small mystery is attached to all this, since the Leitz archives indicate that Eckener was given number 10,000, and that 280 was given to Zeppelin. Van Hasbroeck has advanced the plausible explanation that Eckener and Zeppelin exchanged cameras, which would explain how the industrialist's grandchildren came into possession of 280.

On its around-the-world trip zeppelin LZ 129 crossed the Soviet Union, flew over India and China, and stopped

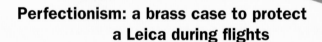

Perfectionism: a brass case to protect
a Leica during flights

Zeppelins flew at high altitudes, so to protect the Leica from the possibility of condensation, with the consequent formation of water inside the camera, a very special brass case (above) was designed and made. The case, lined in red velvet, was composed of two bodies that interlocked perfectly, guaranteeing an air-tight seal. Brass was chosen because of its qualities of malleability and elasticity; its pliability would help protect the camera in the case of a hard knock or bump, since the metal would absorb almost all of the blow. The case was designed to stay closed even if the Leica inside it was damaged in an accident, thus at least preserving intact the roll of film, which could then be later developed.

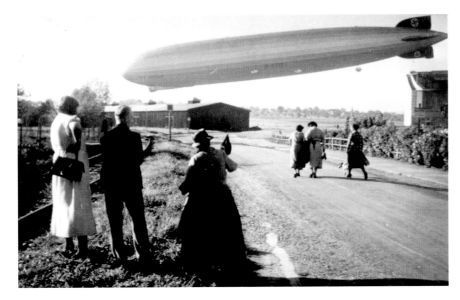

Flying over Giza

Left, the departure of a zeppelin dirigible from the Friedrichshafen "station" during the 1920s.

Below, an image of the pyramids of Giza taken from zeppelin LZ 127, piloted by commandant Hugo Eckener, friend of Oskar Barnack.

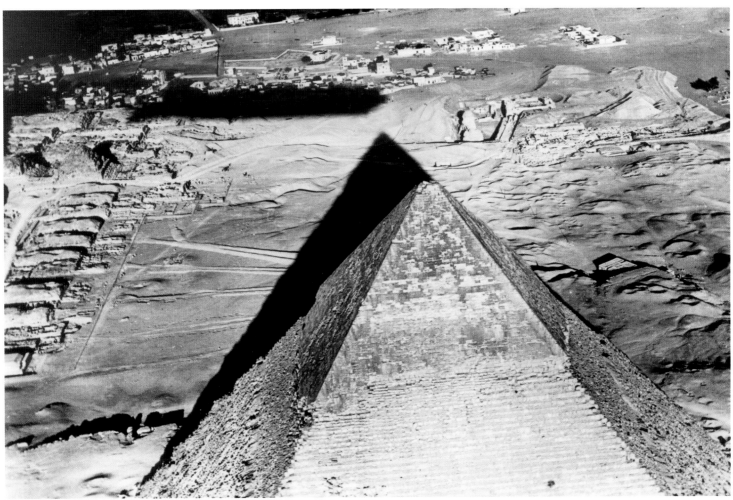

in Tokyo before taking on the Pacific Ocean and the next leg, in the direction of California. Whether it is a fable or mere coincidence, the fact is that the Japanese, having seen the Leica around Eckener's neck, copied it immediately, producing a completely similar model with the brand name Kwanon (today Canon). Initially the Japanese limited themselves to reproducing the Leica I, then they began improving the product, even anticipating several improvements that Leica introduced over the course of its history. For example, as early as 1946 the Canon S II had its rangefinder in the viewfinder (thereby eliminating the use of two parallel eyepieces, one for focusing and one for viewing), and the Canon II B of 1949 was the first camera with frames in the viewfinder for three lenses of different focal lengths. Not until 1953, with the M series, did Leica reach that point.

45

Leica II

Leitz made a sensation again at the Leipzig fair when it presented the Leica II in 1932. The main innovation was the built-in rangefinder coupled to the lens. This system, controlled by the focusing lever around the lens, used two prisms that coincided to form a single image of the subject when it was in focus. If the subject appeared split, the focusing distance was incorrect. The only difficulty was the fact that the eyepiece of the rangefinder was separated from the eyepiece of the viewfinder, so the photographer had to first look in the rangefinder eyepiece to focus and then in the viewfinder to frame the scene. This called for a certain agility in moving the eye from eyepiece to eyepiece, particularly if the subject was in motion. Another step ahead was the coupling of all the lenses of the Leica family with the rangefinder and the birth of universal viewfinders for wide-angle and telephoto lenses. The Leica II also introduced the extendable rewind knob, making the operation easier to perform.

Finally, following a production logic that Leitz was to follow in the coming decades, a Leica I could be updated to the new model, maintaining its original serial number. The Leica II remained in production until 1948, although the bulk of the production took place during the prewar years of 1932–39, when 39,936 cameras were made.

Film advance

Finely knurled and slightly raised, this knob served to advance the film and to set the shutter. At its base is the automatic frame counter.

Shutter-release button

Identical to that on the preceding model, it maintained the famous ease of use, and the shutter was still extremely silent.

Shutter speed

The shutter speeds were the same as those of the Leica I, from 1/20 to 1/500 of a second plus the Z setting for slower speeds.

Reversing knob

The small knob disengaged the film so it could be rewound. In 1930 Kodak and Agfa introduced lightproof film canisters.

Coupled rangefinder

The circular eyepiece to the left and the square one in the middle are the viewers for focusing the incorporated rangefinder.

Rewind knob

A knurled knob served to rewind the film. Its small size made it somewhat awkward to use.

The Leica "Iceman"

Below, like the prehistoric Iceman found in the Alps, this Leica II was found in 1994 in the glacier of Wielinger Kees in Upper Thuringia, at 2,200 meters of altitude. The camera body and lens survived the weather and the pressure of the ice. Leitz archives indicate that the camera was sold on April 11, 1932, to a Mr. Jansen.

Standard lens

Leicas were supplied with the classic collapsible 50mm Elmar f/3.5. The more luminous Elmax f/2.5 was also available.

Focusing mount

The lens was focused by turning the lever to the left of the lens mounting, coupled to the new rangefinder.

Technical data

Rarity grade:	●
Years of production:	1932-1948
Serial numbers:	71,200 to 358,650
Quantity produced:	52,509
Finish:	black and chrome
Lens:	interchangeable screwmount
Shutter:	focal plane
Viewfinder:	incorporated
Rangefinder:	incorporated
Self-timer:	no
Strap lugs:	no

Note: In 1932 a new short telephoto lens, the Elmar 105 f/6.3 was presented, made especially for portraits and for mountain photography, usable with the incorporated rangefinder.

Leica 250 Reporter

Also known as the 10-meter Leica because of the enormous quantity of film it could hold, the Reporter was an enlarged Leica III, with a large spool chamber on each side making possible 250 frames. Special cassettes were designed for this camera; these had to be loaded in the dark but could be installed in daylight. To avoid long rewinding, the spool that received the film, the one on the left looking at the camera, could be extracted. The Reporter was in official production from 1934 to 1943, with only 984 units made, although small lots were delivered on request to special clients until 1953. It was the last project designed by Barnack, who fell seriously ill a short time later. According to another one of those legends that circulate in the world of Leica, the idea had come to him while he was trying to meet the request from a professional photographer in Belgium who worked in the cathedral of Brussels photographing weddings and religious services and wanted a way to avoid having to constantly reload his camera. The German Luftwaffe thought highly of the Reporter for use in aerial reconnaissance and ordered 200 from Leitz equipped with an electric motor to advance the film.

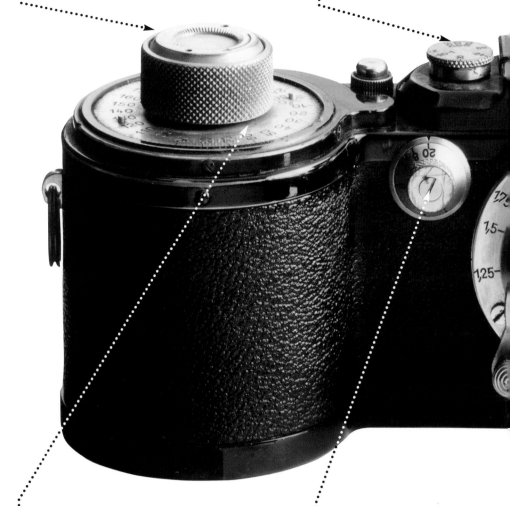

Film advance

To make advancing the film easier, the knurled knob was nearly twice the size of those used on traditional Leicas.

Fast-speed dial

On the top of the camera was a dial for setting fast shutter speeds; the scale is from 1/20 second to 1/500 for the Reporter FF and from 1/20 to 1/1000 for the Reporter GG.

Frame counter

As in all Leicas, the frame counter was located on the left; it automatically advanced up to 250 shots. The numbers advance in groups of ten.

Slow-speed dial

Like the Leica III, the Reporter had a button on the front to set slow speeds from 1/20 to 1 second.

Improved rangefinder

Beginning with the Leica III the rangefinder was improved with an enlargement lens that increased its vision by one and one-half times.

Diopter adjustment

Near the rear eyepiece of the viewfinder is a lever to adjust the vision for those with vision defects

Standard viewfinder

This camera had a viewfinder for the standard 50mm focus-length lens like the other Leicas.

Large loader

To hold the special 250-shot rolls the end spools of the Leica were enlarged, but without compromising the camera's proverbial ease of handling.

New lenses

Beginning in 1933, along with the Elmar a new 50mm lens was produced, the Summar f/2 in a fixed collapsible mounting, along with the 135mm Hektor f/4.5.

Technical data

Rarity grade:	● ● ●
Years of production:	1934-1946
Serial numbers:	130,001 to 353,754
Quantity produced:	984
Finish:	black and chrome
Lens:	interchangeable screwmount
Shutter:	focal plane
Viewfinder:	incorporated
Rangefinder:	incorporated
Self-timer:	no
Strap lugs:	yes

Note: The first cameras were marked FF; their fastest shutter speed was 1/500, and they were based on the Leica III. Those with speeds of 1/1000 of a second bear the mark GG.

Leica IIId

In 1933 Leitz presented a new model, the Leica III, which was distinguished by several improvements: it had strap lugs, an improved rangefinder with a magnification lens for more precise focusing, and a selector dial mounted on the front of the camera for slow shutter speeds, which on the Leica II had stopped at 1/20 second. The new system made possible even slower speeds, up to 1 second. The camera was available in either black or chrome finish.

In 1940 the IIIc was put into production. Its body was 2.8 mm longer and was diecast, with the top plate and rangefinder cover forming one piece. Two versions of the Leica IIIc were produced: one prewar, distinguished by the advance-rewind lever being located on a small platform, or step, and a postwar version without the step and with serial numbers that begin at 400,001. During World War II a double-face black-red fabric, more fragile than the usual material, was used for the shutter curtains: these cameras, known as "red curtain" Leicas, are very rare. In 1940 the IIId was introduced, the only difference being the presence of the self-timer mechanism, a lever located near the button of the slow-speed dial.

Film advance

The system of film advance remained unchanged in the III series, with a large knob advancing the film and setting the shutter.

Double threading

In 1941 double threading was used around the shutter-release button so that a cable release could be attached without removing the guard.

Faster speeds

Beginning with the IIIa in 1935, the Leica III had even faster speeds, up to a thousandth of a second.

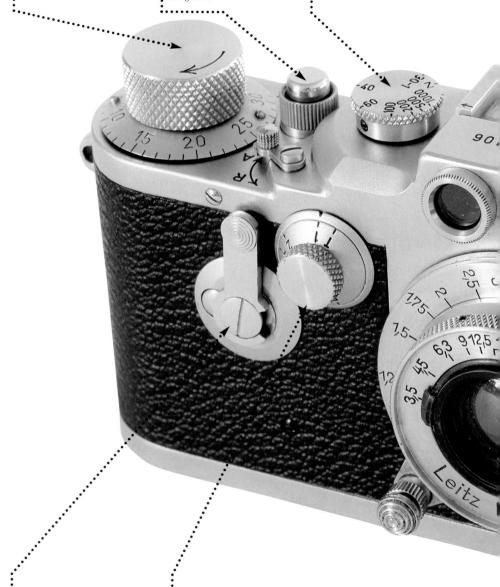

Self-timer

The Leica IIId is the only one with a self-timer, set using a lever to the left of the slow-speed dial.

Slow-speed dial

From the technical point of view, the fundamental improvement was the possibility to take pictures at slow speeds of 1/20 of a second up to 1 second. Slow speeds were set using a selector dial mounted on the front.

Accessory shoe

Among the improvements of the Leica series III is the accessory shoe, enlarged and provided with four screws instead of three to improve connections.

Diecast body

Beginning with the Leica IIIc the rangefinder cover and the top plate were a single diecast piece. Beginning with the IIIb the eyepieces of the rangefinder and the viewfinder were placed immediately adjacent to each other.

Diopter adjustment

With the Leica III the lever for diopter adjustment in the viewfinder (to make up for vision defects) was moved to the side of the eyepiece, at the base of the rewind knob.

Strap lugs

Beginning with the Leica III strap lugs were introduced, which previously had been attached to the camera's leather case.

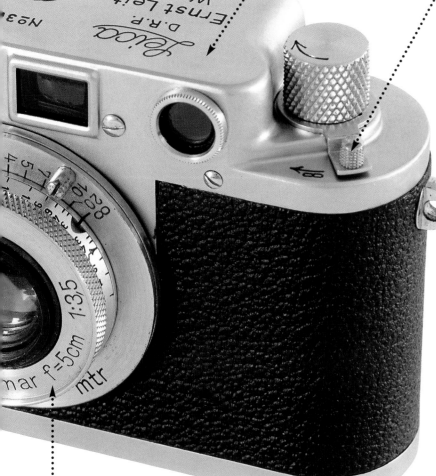

New lens

Along with the 50mm Emar, Elmax, and Summar, production began in 1939 of the Summitar 2/50, the first with lenses to undergo treatment to diminish reflections.

Technical data

Rarity grade:	● ● ●
Years of production:	1940-1945
Serial numbers:	360,022 to 367,325
Quantity produced:	427
Finish:	chrome
Lens:	interchangeable screwmount
Shutter:	focal plane
Viewfinder:	incorporated
Rangefinder:	incorporated
Self-timer:	yes
Strap lugs:	yes

Note: The IIId is the IIIc fitted with a self-timer; it has the step, and some models have the red shutter curtains made with fabric from Kodak.

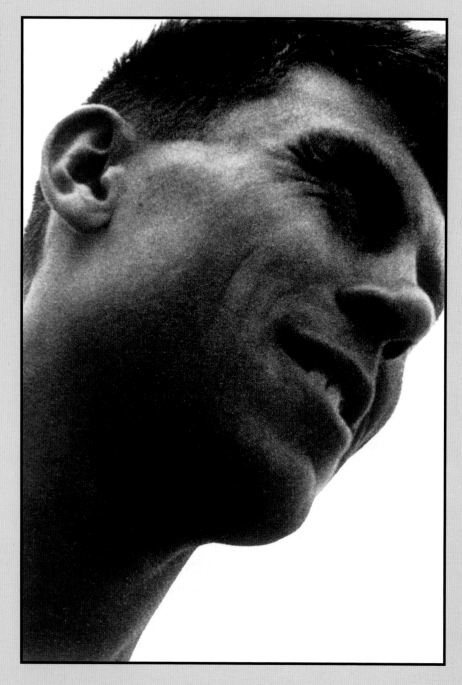

Alexander Rodchenko, the avant-garde in the USSR

In 1920, following the revolution and the civil war, the Soviet Union under Lenin went through a fifteen-year period of great creativity in the arts. The creation of a new society, socialist and egalitarian (at least in theory), gave a charge of vitality to developments in the figurative arts as well as in poetry and literature. Experimentation was the order of the day, and a generation of artists—from Vladimir Mayakovsky to Ossip Brik, from Michail Bulgakov to Boris Pasternak and Maksim Gorky—threw itself into the challenge to create a destructured art, of the people and free of aestheticism. Alexander Rodchenko (1891–1956) was one of the leading lights of this exciting era, first as a "painter" disciple of the volcanic Marcel Duchamp, then as a photographer. The discovery of the creative possibilities of photography coincided with his "discovery" of the Leica during a trip to Germany; with its compact size it proved the perfect tool for Rodchenko to capture the flow of life in Moscow and among his artist friends. The photo opposite, Girl with Leica, is from 1934; the angles and intersecting diagonals that compose the image locate the subject in an asymmetrical position. The same unusual perspective appears in the image to the left, the 1932 portrait of Sergei Urusevsky, a student of Rodchenko who became a director and cinematographer. For Rodchenko, as for Duchamp, the line was everything. This artistic movement ended under the Stalinist repression, which became increasingly violent during the second half of the 1930s, when all the arts were forced to adhere to the rigid directives of socialist realism.

Sergei Urusevsky, 1932

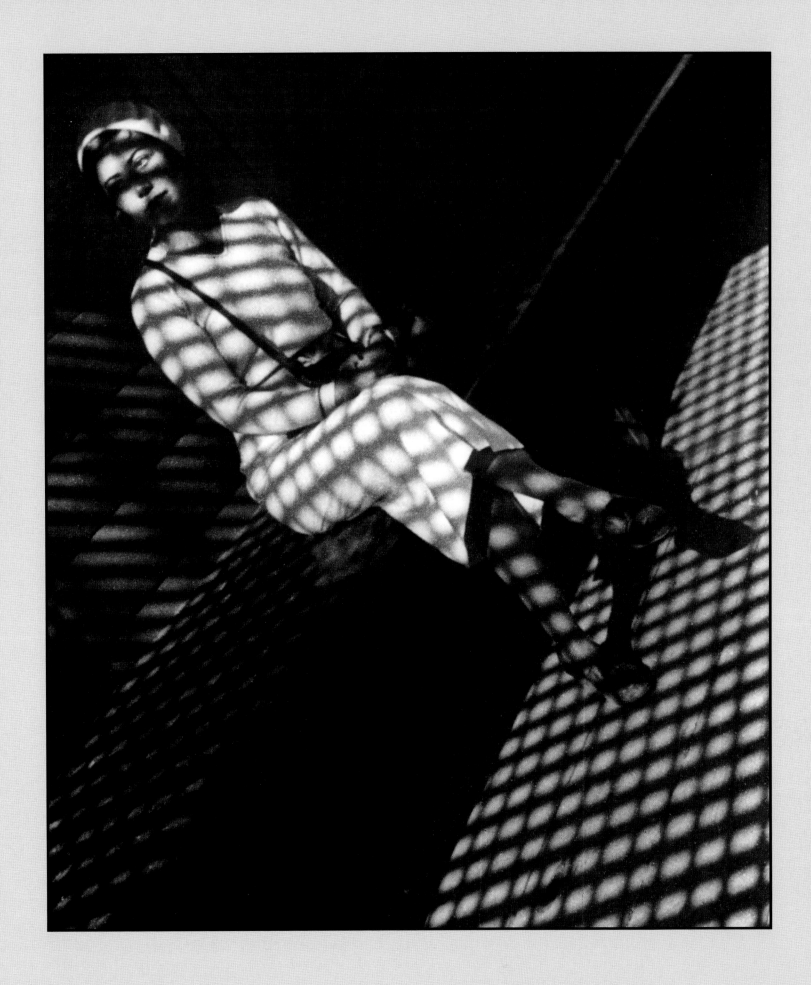

Girl with Leica, 1934

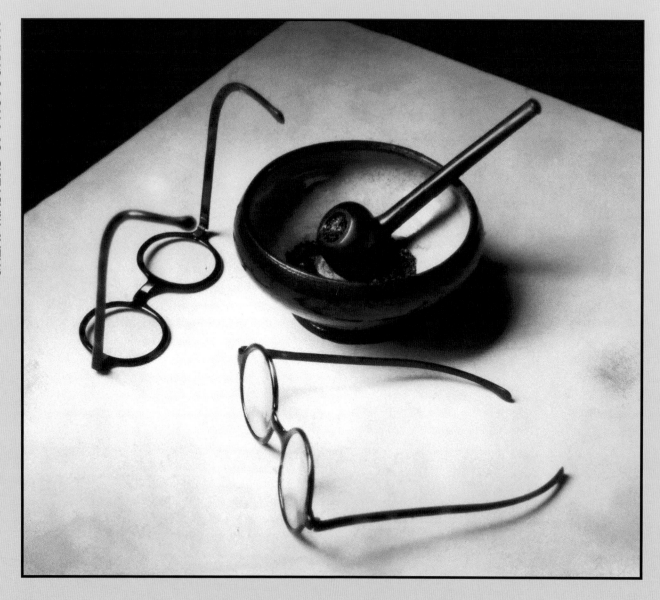

*Mondrian's
Eyeglasses and Pipe,
Paris, 1926*

André Kertész, an eye for daily life

The Leica soon became the favorite camera of photographers throughout the world. Among the first to discover its qualities of rapidity of use and quality of final image was André Kertész (1894–1985), who was born in Budapest in 1894, moved to Paris in 1925, and then to the United States in 1936, becoming a citizen in 1944. While in Paris he took pictures documenting daily life in the French capital. His work followed two basic themes, portraiture and the small facts of existence, and he carried these to the border of abstraction. The images presented on these two pages are typical of Kertész's rigorous conceptualism. The first, above, immortalizes the pipe and eyeglasses of the famous Dutch painter Piet Mondrian (1872–1944). Its geometric composition reveals much of the abstract potential of photography. The second image, opposite, presents the surprisingly artistic dimensions of a quite ordinary daily object. Kertész often cited the one rule that guided him in photography: "My camera is of extreme simplicity. The only absolutely indispensable quality for achieving success with a portable camera is patience."

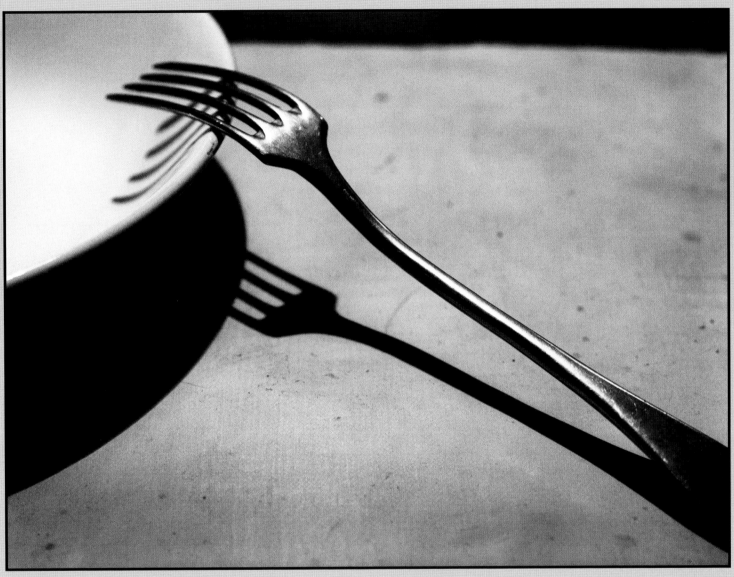

Fork, Paris, 1926.

Henri Cartier-Bresson, capture the moment

"What is photography? . . . To take photographs means to recognize . . . both the fact itself and the rigorous organization of visually perceived forms that give it meaning. It means seizing the moment. It is putting one's head, one's eye, and one's heart on the same axis." Henri Cartier-Bresson, born in 1908, considered one of the twentieth century's most important photographers, always followed this simple rule. His images, so apparently casual, literally revolutionized the way the world, people, and great events are portrayed. They also trained later generations of photographers throughout the world. The image to the right is an excellent example of Cartier-Bresson's style, his way of telling a story in a picture. This is a scene from the daily life of France, a working-class family out for a Sunday picnic: "On the Banks of the Marne," 1938. The "moment" is the man to the left in the photograph, captured while pouring wine. Everything seems to have been arranged to meet the photographer's needs, the empty plate with the fork, the overturned bottle, the woman eating chicken with her hands.

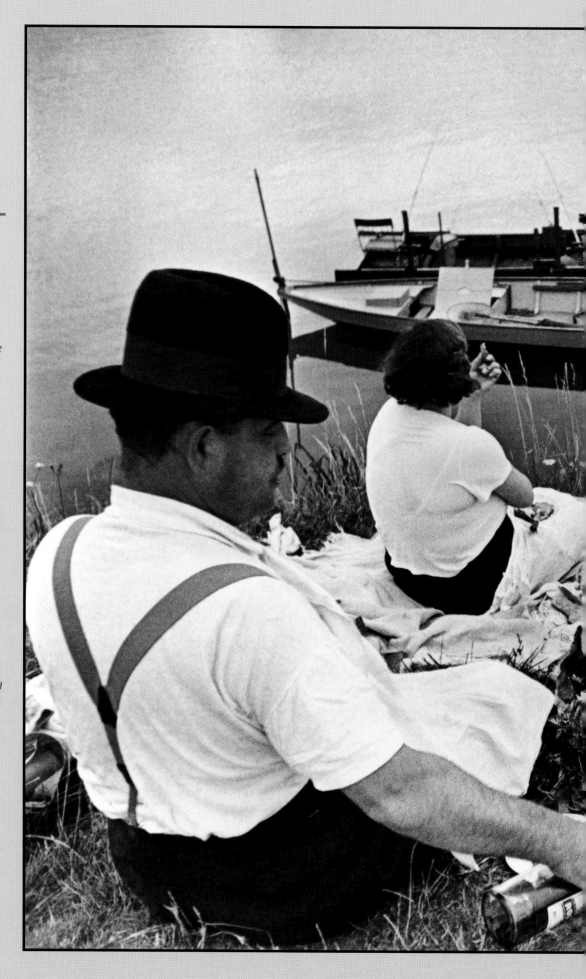

On the Banks of the Marne, 1938.

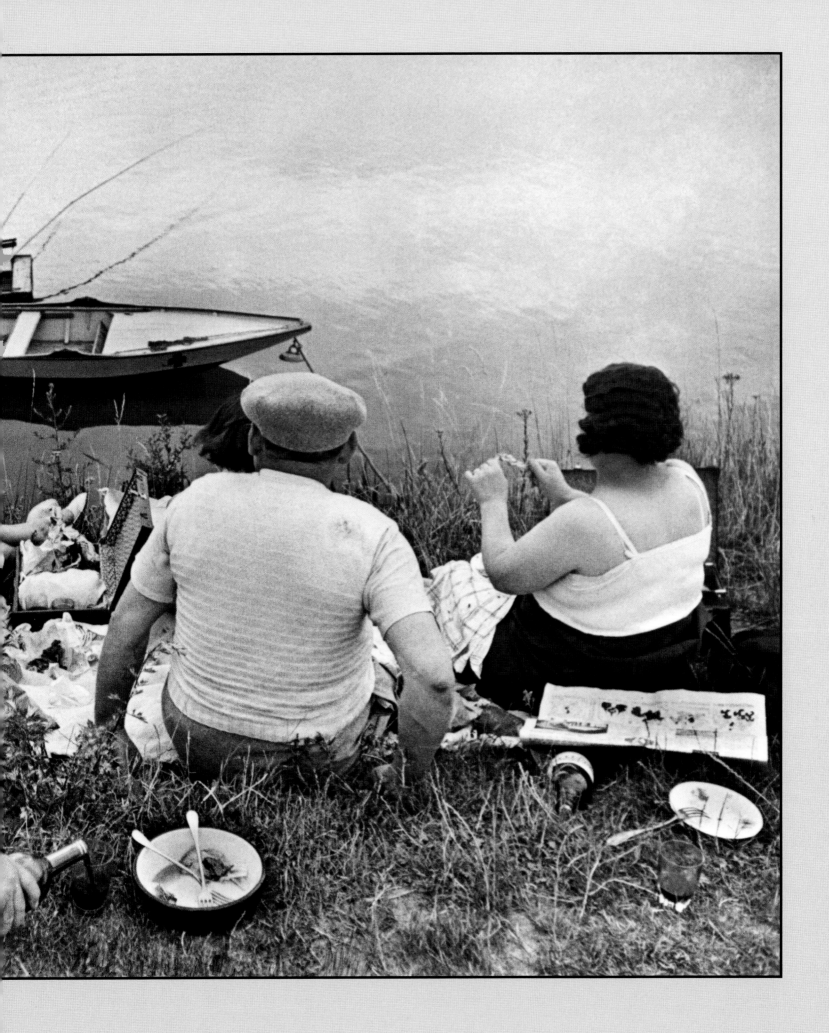

X-ray of success: the power of advertising

A popular star

Above and below, advertising images of the Leica from 1929 to 1935. There are two themes to the message: the Leica is a star of photography, and it is a camera that lets everyone take beautiful and surprising pictures.

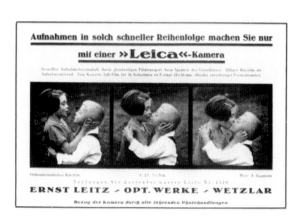

One of the factors behind the worldwide success of Leica in the period before the outbreak of World War II was its commercial drive, which was completely exceptional for the period and equal in inventiveness to the company's technicians. Aside from Carl Zeiss of Jena, Leitz was the only company in the optics-photography field to develop a world network of vendors, in Europe and then in the United States, where Leica enjoyed an immediate and predictable success. Karl Koch, director of sales, developed the commercial policy of Leitz not only through traditional publicity, but also by financing publications that illustrated the new camera's abilities and potentials. The first magazine dedicated to the Leica, *Die Leica*, appeared as early as 1931; it was closely followed by *Leica News and Technique*, for the English-speaking world. The postwar period saw the launch, in 1952, of *Leicaphotographie*, issued in three languages, German, French, and English. Today Leica

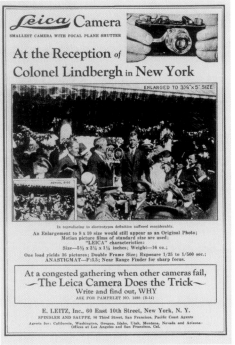

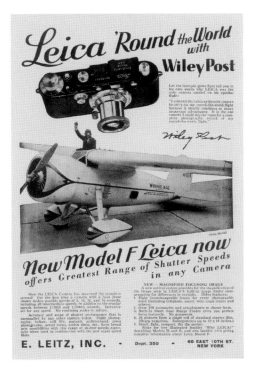

publishes a biannual *Leica World* and in Italy a bimonthly *Leica Magazine*. Aside from magazines Leitz sponsored photography exhibitions, beginning with the images of Paul Wolff, which, enlarged to the 30 x 40 cm format, made their own contribution to spreading Barnack's slogan, "small negatives, large pictures," and attracted

Latin passion

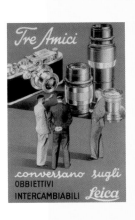

During the 1930s the Leica was also rapidly gaining fame in Italy. After a brief period in which the camera was imported by a branch office of Leitz, the distribution was entrusted to a company in Genoa, Ippolito Cattaneo, which handled its sales until the 1980s. This is one of their first ads, a 32-page booklet from 1936 that calls attention to the Leica's use of interchangeable lenses. The title of the booklet, *Tre Amici* ("Three Friends"), refers to the amateur, Gustavo, who always works with a large-format, 10 x 15, lens; the beginner, Adalberto, who has only recently purchased his Leica; and the Leica master, Ludovico, who has been using a Leica for many years and declares that he will remain faithful to it forever.

the attention of amateur photographers. And Leica was present at great happenings. Here above are two publicity flyers made for the American market. The one in the center refers to the reception given Charles Lindbergh following his first transatlantic flight, in 1927; the one to the right (1933) bears a testimonial from another adventurous pilot, Wiley Post, who unfortunately crashed in Alaska during an attempt to fly around the world.

In all of its advertising images Leitz insisted on two fundamental points: the first, that the Leica was the camera most in demand, a true star among cameras; the second, that it was within the reach of everyone, including women, and that it had a speed of action unknown to any of its competitors, a speed that was made clear in the series of two children kissing. In a short time the Leica had conquered the most important photographic markets along with the front pages of the illustrated magazines that were beginning to fly off presses in those very same years. World War II brought a halt to this progress, but the reporters active on the war's many fronts did much to increase the fame of the world's best camera.

A world market

Above, three examples of Leica publicity. The first is for the Italian market and emphasizes the strength of the brand. The other two, made for the American market, make connections to two famous aviators, Charles Lindbergh and Wiley Post.

Leni Riefenstahl, an apolitical aesthetic

Helene (Leni) Bertha Amalie was born in Berlin on August 22, 1902. Over the course of her long life she has never quit being a director and photographer. She began, during the 1920s, as a ballerina and actress, but a knee injury forced her to move behind the camera. After seeing one of her films, "The Sacred Mountain," Adolf Hitler asked her to film the activities of the Nazi regime, from the 1934 party convention in Nuremberg ("Triumph of the Will") to the 1936 Olympics ("Olympia"), a feature film that earned her world fame. Her relationship with the Nazis provided Riefenstahl with access to technical means and abundant financing. So taken was Hitler with her creations that he advised his personal photographer, Heinrich Hoffmann, to learn from her. Riefenstahl worked among the highest-ranked Nazis, with direct access to Hitler, and had to put with up the unwanted advances of Dr. Joseph Goebbels, the Third Reich's minister of propaganda. After the war Riefenstahl sought to expiate her relationship with the Nazi regime, declaring herself an apolitical artist. When asked why she had agreed to make a film like "Olympia," which consecrated Nazism, she responded: "'Olympia' was most of all a way to propose the idea of peace. Sports are a positive expression of life. I agreed to make the film for that reason. As for 'Triumph of the Will,' that film was nothing more than a documentary of a convention. Nothing more. I only had to explain what was happening, and the images are often worth more than the words. But the images had to be clear and unequivocal. I was never a Nazi, but I can't deny having admired Hitler."

In the 1960s, in an effort to put her overly close relationship with Nazism behind her, Riefenstahl began dedicating herself to reporting on Africa. She spent twenty years visiting the Nuba people of the Sudan, moving from the glorification of the body of the white race to that of the body of the black. Some of her images of the Nuba appear later in this book. In her seventies she returned to documentary filmmaking, taking courses in skin diving to take underwater photographs. She marked her one-hundredth birthday with the release of a movie composed of her underwater work, "Impressionen unter Wasser" ("Underwater Impressions").

The long jump at the 1936 Berlin Olympics.

60

The American athlete Jesse Owens at the 1936 Berlin Olympics.

GREAT MASTERS OF PHOTOGRAPHY

Gisèle Freund, the force of a refusal

Leni Riefenstahl and Paul Wolff accepted the Nazi regime in an instrumental way, in the name of their art, in order to be able to work without concern for the brutal face of the dictatorship. The attitude of another great photographer, Gisèle Freund, was the complete opposite. Born in Berlin like Riefenstahl, the daughter of an art dealer, she studied sociology under Karl Mannheim and Norbert Elias, assistant to Theodore Adorno and Herbert Marcuse (founders, along with Max Horkheimer, of the Frankfurt Institute of Social Research and Marxist theorists very popular during the student revolts of the 1960s in the United States and Europe). Encouraged by Elias, she began to study the social values of photography. A firm anti-Nazi, as well as the editor of a university newsletter, she had to flee Frankfurt to escape arrest, leaving by train one night in May of 1933 and arriving at the Paris station at six in the morning. The images on these pages date to her Parisian period, before the war began, when she became a member of the circle of intellectuals—including Sylvia Beach, James Joyce, Walter Benjamin, and André Gide—that used the Shakespeare & Co. bookstore as their meeting place. When the Germans invaded France, Freund fled Paris and spent two years hiding in the countryside in a town in the Dordogne. Thanks to the help of the Argentine writer Victoria Ocampo she obtained a visa for Buenos Aires, which she reached by sea, leaving from Portugal. In Argentina she did as she had in Paris and became a member of intellectual circles, making friends with Jorge Luis Borges and managing to photograph Evita Peron. In Mexico she became close friends with the painter Frida Kahlo. Freund returned to Europe in 1947 and began working for the nascent Magnum agency, founded by the best photographers of the period, from Capa to Cartier-Bresson. In 1974 she published a book of reflections on the social value of photography, Photography & Society, a fundamental text in the understanding of the meaning of images. She has never quit taking pictures and has never abandoned her Leica.

Walter Benjamin, Paris, 1937.

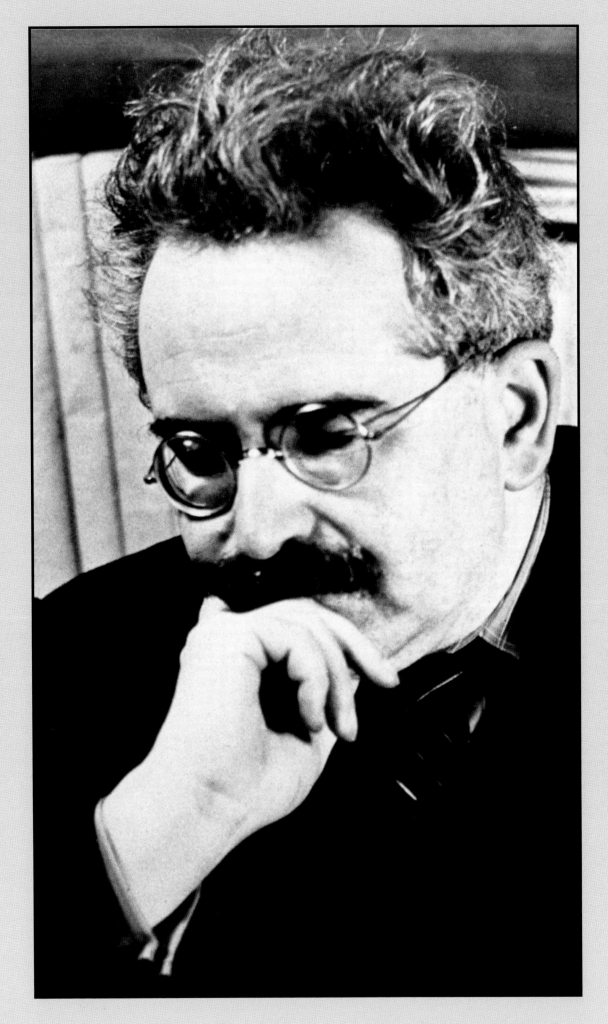

The Leica goes to war

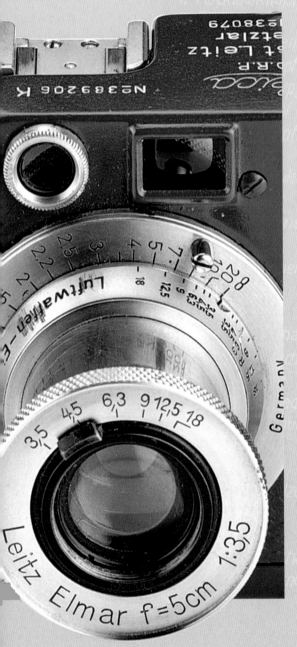

In 1939, on the eve of World War II, Leica occupied a position of enormous prestige among photographers, who by then had learned the wonderful qualities of that handy and precise camera. But destiny is blind, and the tools men make are themselves innocent. From September 1, 1939, until the end of the war, the Elmar and Hektor lenses no longer opened on the smiling faces of girls and children, they no longer transferred to film the discovery of the world seen from above and from every other possible angle or reflection. Instead, they opened to document images of armed men, Panzer tanks and bombers, the advance and then the inglorious retreat of the Nazi swastika, with scenes of destruction in the middle. As humanity deserved, the war finally ended, and the joy of peace returned, along with the joy of life. And life once again became the subject to be photographed, and just as it really is, without assuming poses, so as to take its rightful place in the album of personal and collective memories.

Ernst Leitz II, a man without shadows

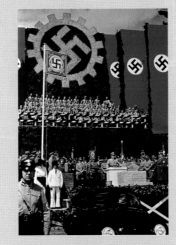

Robert Capa, reality recorded live

Adolf Hitler: photography in the service of propaganda

Peace and the rediscovery of the joy of life (and of photography)

The Nazi period: from apotheosis to disaster

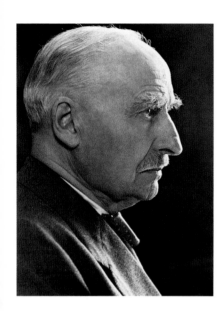

In his hands

Above, Ernst Leitz II. During the war, the industrialist, by then in his seventies, never abandoned his place of work, even spending nights in the factory. He said that only in that way could he make the necessary immediate decisions in case of a bombardment.

Celebration of 70 years

Right, the celebration of Ernst Leitz's seventieth birthday, held in the factory on March 1, 1941. Despite the banners with swastikas, Ernst Leitz had not invited members of the Nazi party, an affront to the regime that might have had serious consequences for the company. As it happened, there were no reprisals.

Leitz grew quite a bit during the years preceding World War II. Aside from cameras, the company produced microscopes and movie cameras and came to employ more than 3,500 people. From 1932 to 1939, Leica's annual sales averaged between 30 and 50 million units, whereas production during the 1920s had never exceeded 9 million units. On the German market Leica had only one true rival, the Contax, which Carl Zeiss had begun producing in 1932 and which was occasionally used by great photographers, such as Robert Capa, who had one around his neck when he came ashore during the Normandy landings on June 6, 1944. The Contax had been presented at the Leipzig fair, at the same time as the Leica II. Its shutter was revolutionary, being vertical (and not horizontal, such as in the Leica) and made of metal (those of the Leica were made of rubberized cloth). Such shutters were in theory more precise, but in reality they proved less reliable, an endemic fragility that was one of the reasons that Zeiss's camera enjoyed less success than the Leica. In fact, in terms of optics, the Contax had no reason to envy its rival. More than a few of the Leitz lenses were based on Zeiss designs. For example, Leica's 50mm Elmar was an improvement of the Elmax, which in turn was based on the lens scheme of the Zeiss Tessar, and its construction, in 1927, was made possible by the expiration of the Zeiss patent. Even more: for the Contax, the Jena company had immediately presented a superluminous lens that had no rival, the 50mm Sonnar f/1.5, soon followed by another excellent lens, the 180mm f/2.8 made especially for the Berlin Olympics of 1936 and immediately baptized

the "Olympia-Sonnar." But the sturdy bodies of the Leica cameras, the array of available accessories, and the more aggressive commercial drive of the worldwide network awarded success to the cameras invented by Barnack.

World War II brought the most difficult period in the history of Leitz. Beginning in 1940 more and more of the company's production was absorbed by the Nazi armed forces and by the SS divisions of Heinrich Himmler. At the same time, production had to accommodate the increasingly heavy restrictions of the wartime economy. The time came when production of the chrome-finish Leica had to be stopped due to the lack of primary materials, most of all the chrome itself, and for a while the shutters were made using a double-face red-black fabric that the Nazi regime had

sequestered from the Kodak branch in Germany. This material proved too fragile for prolonged use and was abandoned, to be replaced by the material then used for parachutes. All in all, World War II ended the positive historical cycle of Leitz, which survived because of the commissions for the military for the armies of the Axis, including the Italian armed forces. These military Leicas, as we will see further on, are very popular with collectors and are also easy to falsify. Sometimes, all it takes is a revarnishing and a new plate mark to transform a civilian Leica into a military Leica. The war brought Leica new problems, without doubt the worst being total mobilization. Beginning in 1943, as the tide of war turned against Germany, whose armies experienced their first major defeats in the Soviet Union and Africa, all able-bodied men were called to serve, depriving Leitz of its best workers, destined for the front. As in all German factories, their places were taken by the so-called foreign workers, meaning prisoners of war forced to work for the Reich. In 1943 the number of Allied bombers over Germany increased, and even Wetzlar was not spared. Because of the American and English bombings, the seventy-two-year-old Ernst Leitz decided to stay in the factory even at night, in order to be able to take whatever measures were necessary in an emergency. The American soldiers who entered Wetzlar treated the aging businessman with suitable respect. After all, he had not been a member of the Nazi party and had earned respect by staying in place during the war, such that the GI military police said he was a man "without fear and without blame." The Allied

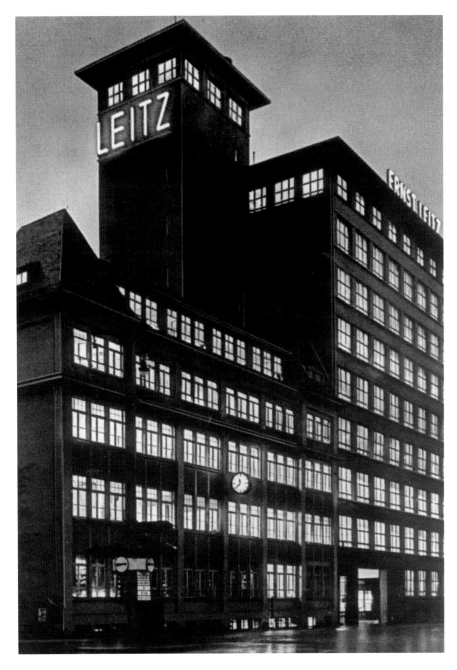

bombings left 4,482 inhabitants of Wetzlar homeless. The entry of the American troops had been unopposed, however, and the inhabitants of the city immediately cooperated with the Americans so well that the factory was able to return to production in June 1945.

The factory

The Leitz factory in the 1930s. The lights were soon turned off due to Allied bombardments.

67

Leon Trotsky, 1932.

Robert Capa, life as adventure

He can be remembered by beginning at the end. At 2:55 in the afternoon on May 25, 1954, Robert Capa, war reporter, was marching alongside French soldiers at Thai Binh, south of Hanoi, when he stepped on a mine. The man who had risked his life during the Spanish civil war in 1936 and the D-Day invasion in June 1944 was thus tricked by fate, becoming the first American reporter to die in Vietnam—and before it became an American war. Born Andre Friedmann in Hungary in 1913, founder, together with

Henri Cartier-Bresson, David Seymour, George Rodger, and Bill Vandivert, of the most famous photography agency, Magnum, in 1947, he was among the first to show us war in all its horrors.

He said, "War should be photographed with a wide-angle lens" to point out that a reporter's place is in the middle of the action, not at some safe distance. More than anyone else, he was the prototype and symbol of the action photographer, incapable of staying put.

At eighteen he left Hungary, where the political climate had

Death of a Republican Soldier, 1936. In 1994, the authenticity of the photo was called into question by an English journalist, who claimed it had been staged. In 1996, however, following detailed research, the soldier was identified by another journalist, Rita Grosvenor. His name was Federico Borrel Garcia, and he died on the Cerro Muriano front.

become unbearable after the government had been taken over by Admiral Horthy, with his pro-Fascist sympathies. He moved to Berlin. There, almost by accident, he began taking pictures for the Dephot photo agency. On November 27, 1932, he found himself sent off on a nearly impossible mission: to photograph Leon Trotsky, in exile in Copenhagen. The former commandant of the Red Army, expelled by Stalin, detested being photographed. Using his Leica, Capa succeeded in taking a picture of Trotsky without Trotsky being aware of it. In 1935, two years after Hitler took power, Capa moved to Paris, where he became engaged to an exiled German photographer, Gerda Pohorylles, who worked under the name of Gerda Taro. Together they set out for the Spanish Civil War (1936), where Capa took his most famous image, The Death of a Republican Soldier, and where he lost Gerda, run over by a tank. Then there was his association with "Life" magazine, for which he worked during World War II and for which he went to Vietnam.

1939–45: cameras in military uniforms

On September 1, 1939, German forces invaded Poland, reaching Warsaw in just three weeks. France and Great Britain declared war on the Third Reich. The production of Leica was increasingly absorbed by the military needs of the German army, air force, and navy. Something similar occurred in England, where the government officially asked his majesty's subjects to hand in their Leicas to make up for the lack of cameras for use in aerial reconnaissance.

The Leicas made for military use include the IIIcK, like the one shown in these photos. This was a Leica IIIc with a white K inscribed on the top plate. The K stood for *Kugellager*, since the shutter was mounted on ball bearings (*Kugellager*) to permit it to function at low temperatures without jamming from the cold. Another, much larger K was stamped on the second shutter curtain. Production of the IIIcK began in 1941 and ended in 1945. Exactly how many Leica made during the war cannot be ascertained, in part because of other cameras that were later made for the

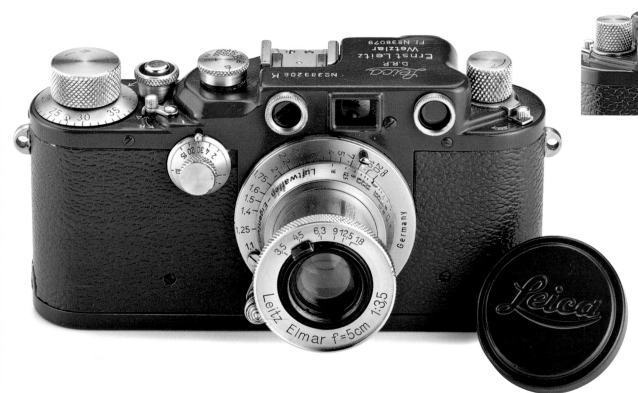

Property of the Luftwaffe

Left and above, a Leica IIIcK made for the German air force, as indicated by the inscription *Luftwaffen—Eigentum*, "Property of the Luftwaffe."

American armed forces, but the number is estimated to be between 2,700 and 5,000. Aside from the K, Leica military cameras are normal cameras that bear an inscription indicating the armed service they were made for. Those made for the army are inscribed "Heer"; those for the Luftwaffe (such as the example shown on these pages) bear writing on the top plate and also on the back, *Luftwaffen-Eigentum*, which means "Property of the Luftwaffe" (in the case of the Ks, near the letter there is also an asterisk). The top plate of the Leicas made for the navy bears an emblem with an eagle holding a swastika inscribed in a crown and beneath it the letter "M"; written on the lenses and on the back of the canister is "W.haven," an abbreviation of Wilhelmshaven, the major base of the German navy. Finally the Leicas made for the artillery are marked "Artl."

All the cameras were marked with the number of the production order, often F.L. 38,078. The cameras for the army were usually finished in black, with the writing printed in white, but Leicas in gray and chrome finishing were also supplied. As for the lenses, Hektor 28mm, Elmar 35mm, Elmar 50mm, the Summitar 50mm, the Hektor 73mm, and the Hektor 135mm can all be found with military markings. Despite the large production, military Leicas have become extremely rare, and thus highly valued, because after the war many examples ended up in private hands, and the new owners, embarrassed by the swastika markings, had all such references to wartime use removed.

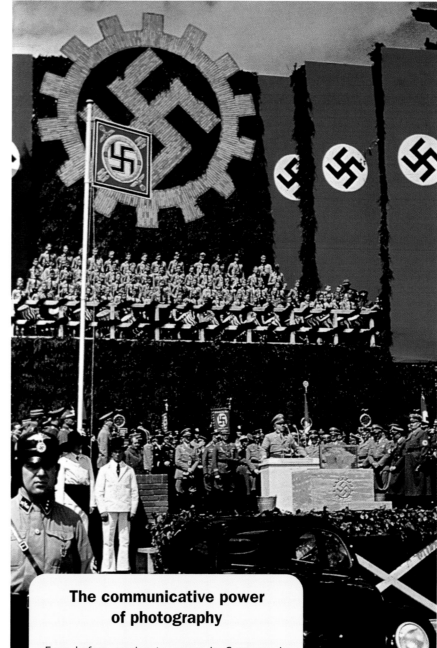

The communicative power of photography

Even before coming to power in Germany, in 1933, Adolf Hitler (1895-1945) understood the propagandistic power of photography. Whether in the hands of the regime's official photographer, Heinrich Hoffmann, or in those of the reporters who accompanied the German army, the Leica was the tool for documenting the ceremonies of the Nazis, the exploits of the military, even the extermination of the Jews. During World War II the Germans in general demonstrated a kind of obsession with photography, taking millions of images in every kind of setting, civilian or military. The photo above shows Adolf Hitler at the ceremony laying the first stone of the Volkswagen plant, on May 26, 1938. The site, a small plain roughly 150 kilometers from Berlin, would eventually be occupied by a new city: Wolfsburg.

Signal: the hazardous birth of front-line reporting

Propaganda

Below, cover of *Signal* (in the edition for the French-speaking territories) from October 1941. Hitler's Germany had been at war for two years, and the propaganda effort was at its peak.

Included within the German armed forces were units of war correspondents who were to follow the battles and advances of Hitler's soldiers, documenting their victories. In the service of the propaganda machine run by Dr. Joseph Goebbels (the Third Reich's minister of propaganda, who committed suicide on April 30, 1945, in the chancellery bunker in Berlin), the reporters were supposed to make films for the regime's news-reels while also taking still photographs (some in color, using the new Agfa film) for the propaganda publications distributed in the occupied countries, the so-called Protectorate of the Reich, which at the highpoint of the Nazi advance ran from France to Poland and included the Low Countries, Denmark, Norway, Bohemia, and Moravia, as well as the other Axis countries, Italy, Hungary, Romania, Bulgaria. The most widely circulated magazines were *Adler* ("Eagle") for the Luftwaffe and *Signal*, the most widespread of all, inspired by the American *Life* magazine. Its strongest features were its full-color cover pictures and its editorial mixture of war events and daily life.

Bulletproof Leica

This Leica II, preserved in the Leica museum in Solms, Germany, belonged to a reporter active on the front lines during World War II. During a battle the photographer found himself under fire. He was saved thanks to the robustness of his Leica: a bullet aimed at him was deflected by the camera he had in the upper pocket of his jacket.

**Carri armati
sul terreno delle esercitazioni**

Giovani carristi che si esercitano col
"Panther", il tipo di carro armato tedesco che ha ovunque dato buone prove

Foto PK: Cronista di guerra Hanns Hubmann

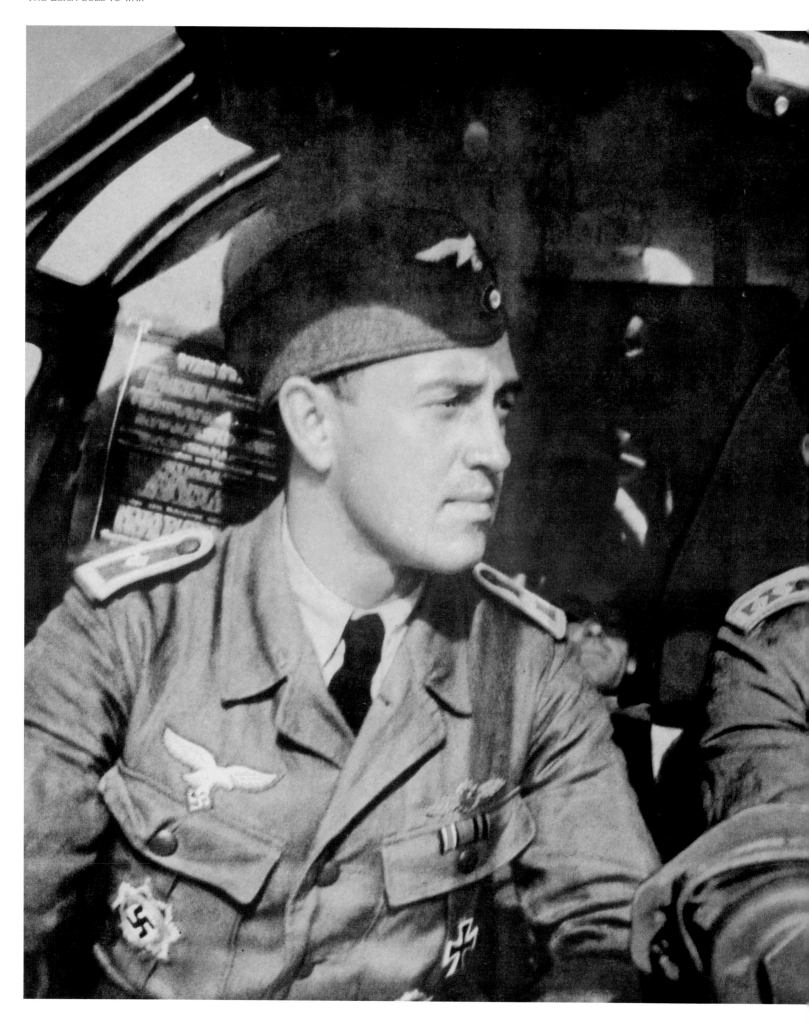

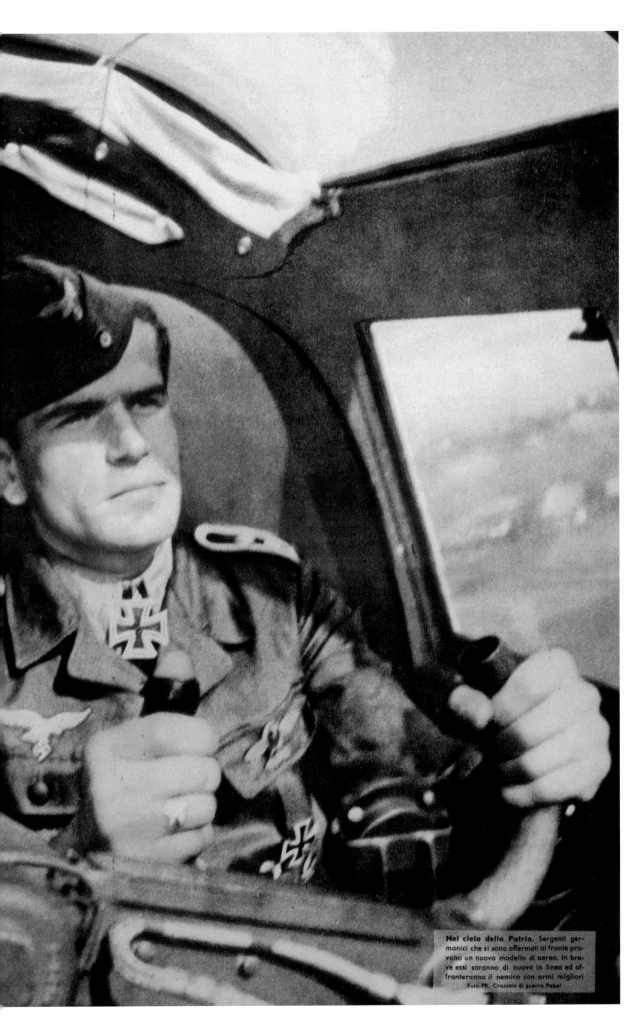

Nel cielo della Patria. Sergenti germanici che si sono affermati al fronte provano un nuovo modello di aereo. In breve essi saranno di nuovo in linea ed affronteranno il nemico con armi migliori
Foto-PK. Cronista di guerra Pabel

Brave airmen

Left, German pilots test a new type of plane. From *Signal*, 1943. In response to a similar image, the German dramatist and poet Bertolt Brecht wrote, "It's we who fly above your city, woman now trembling for your children. From up here we've fixed our sights on you and them as targets. If you ask why, the answer is: from fear."
(Bertolt Brecht, *War Primer*, trans. by John Willett, Libris, 1998)

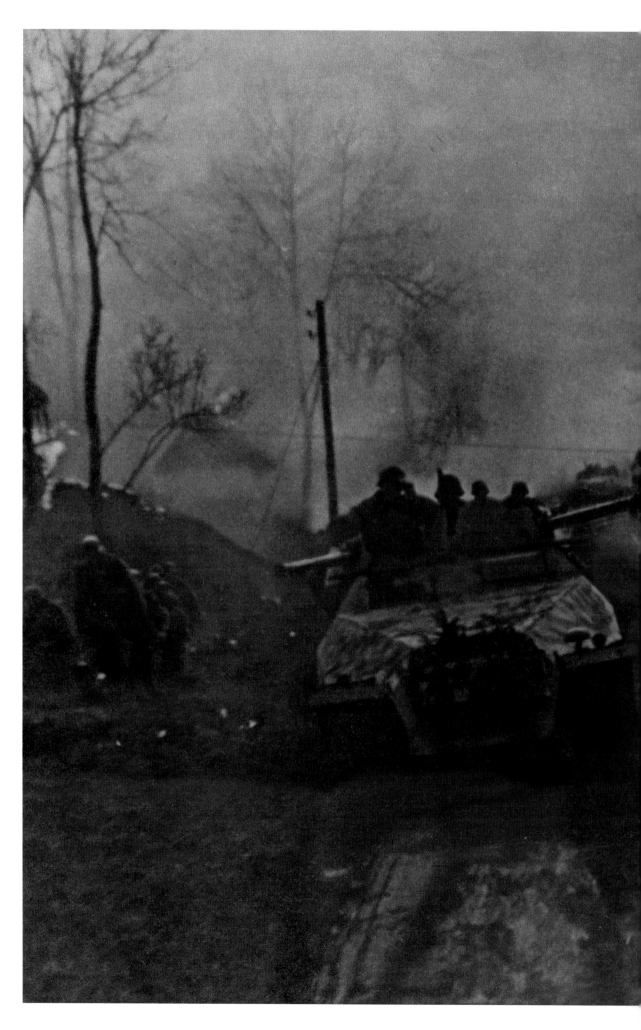

Pictures of real war

Right, from *Signal*, 1944, a
scene of combat on the
Eastern front. Hundreds of
German reporters were killed
in action. Brecht wrote this
epitaph on the conquest of
the countries of Eastern
Europe by the Nazis:
"Suppose you hear someone
proclaim that he invaded and
destroyed a mighty state in
eighteen days, ask what
became of me: for I was there
and lasted only eight."
(Bertolt Brecht, *War Primer*,
trans. by John Willett, Libris,
1998)

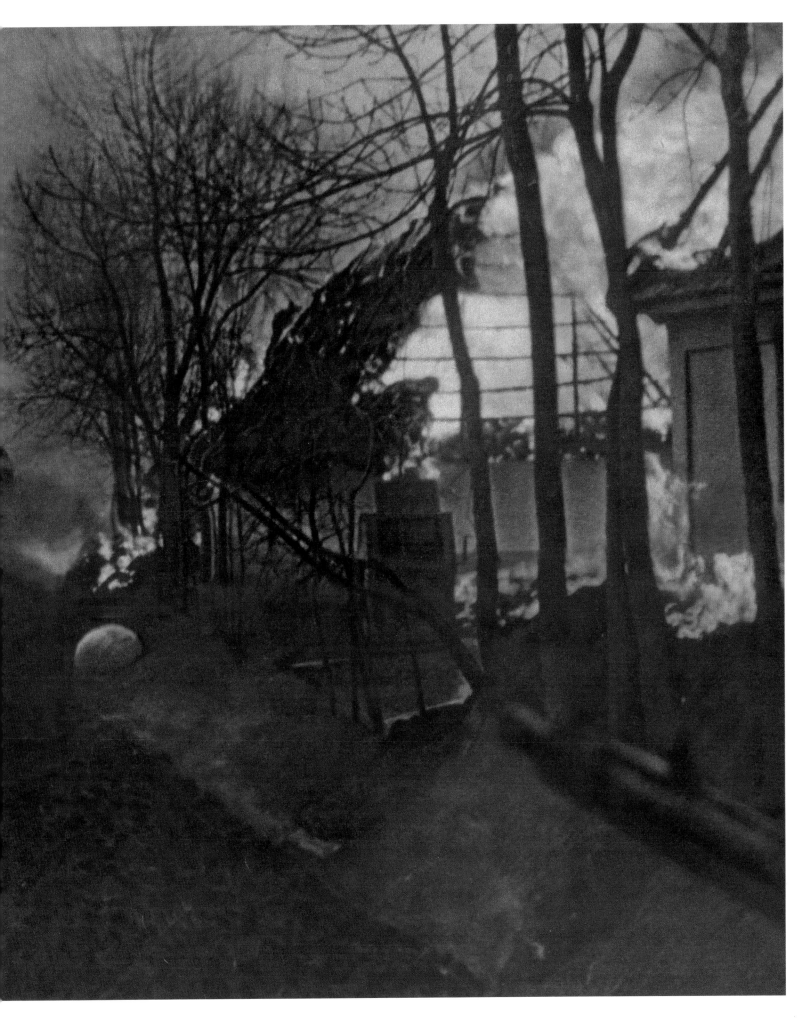

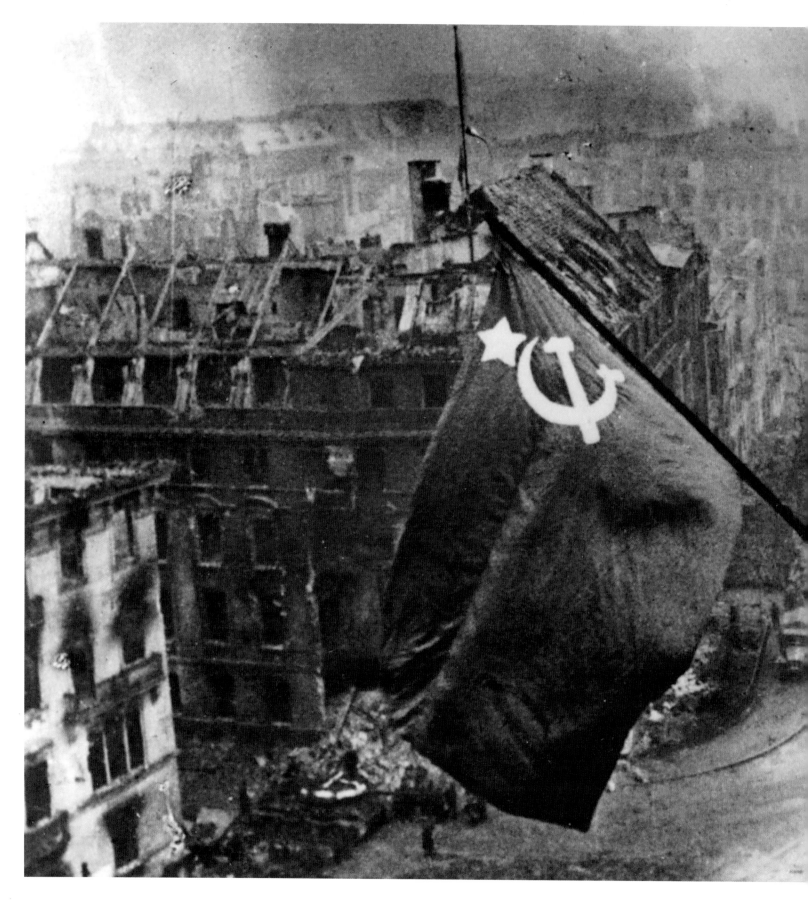

The end of the Third Reich

Above, the red flag of the Soviet Union is raised atop the ruins of the Reichstag in Berlin. The photo was taken early in May 1945 by Yevgeny Khaldei, a Red Army reporter who accompanied Stalin's troops in their advance from Moscow to the German capital, a Leica around his neck.

This photograph has been retouched: in the original, the second soldier was wearing two watches, one on his right wrist, obviously spoils of war. Stalin had the watch "deleted" so that the Red Army soldier would not be taken for a thief.

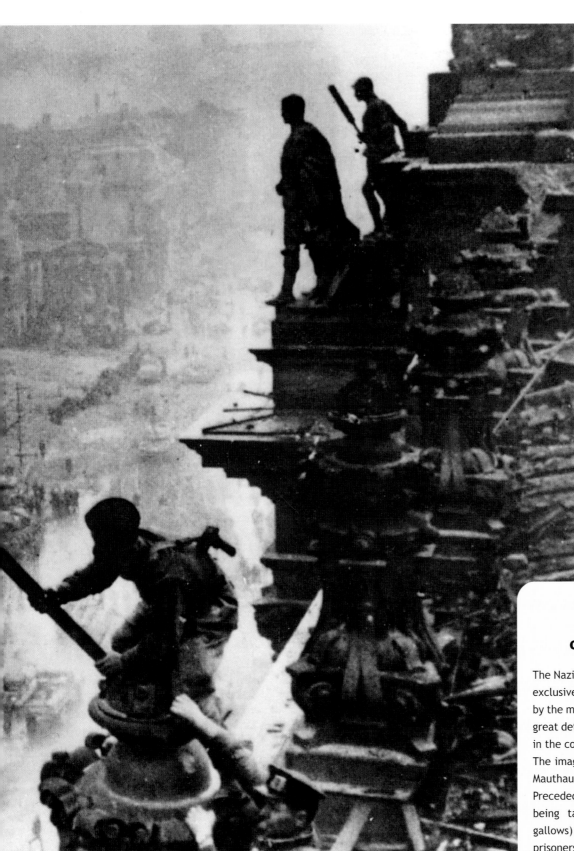

Documenting the concentration camps

The Nazi obsession with documentation was not exclusive to the army, being shared in particular by the members of the SS, who photographed in great detail the inhuman barbarities committed in the concentration camps throughout Europe. The image above was taken by an SS officer in Mauthausen, a camp near Linz, Austria. Preceded by the camp musicians, a prisoner is being taken to the place of execution (a gallows) on a cart pulled by other Jewish prisoners. Such executions were quite common, carried out whenever there was someone to punish, often prisoners who had tried to escape. To the Nazi way of thinking, the executions provided a good example for the other prisoners. The Allied troops that liberated the camps found thousands of such photographs documenting the Holocaust.

USSR: Stalin wants it too:
the production of Leica copies begins

The dictator's dream

Right, Joseph Stalin (center) at the Potsdam Conference in 1945. Stalin wanted a national camera industry, and it was achieved by copying German models, beginning with the Leica.

Beginning in the 1930s, with the first five-year plan under Stalin, the Soviet Union developed a camera industry of a certain importance, at least in terms of the number of cameras made (more than 700,000 units). As for the models, the Soviet technicians, paying no heed to the international patents that protected numerous technical details of the Leica, beginning with the incorporated rangefinder, copied Leicas and other German cameras (the Contax and bioptic Rollei did not escape this plagiarism). One of the most interesting copies of the Leica, produced until the mid-1950s, is the FED (large photo). The camera gets its name from the initials of Felix

Edmundovich Dzerzhinsky, head of the Soviet secret police, first the Cheka and then the GPU and OGPU (forerunners of the KGB). The factory in Kharkov, Ukraine, where they were made was so dedicated to this powerful politician that until 1953 the words "Felix Edmundovich Dzerzhinsky Factory" appeared (in Cyrillic, of course) beneath the FED logo. Following Stalin's death the director of the secret police, who (it was discovered) had been responsible of innumerable atrocities and executions of "traitors to Socialism," was discredited, and his name disappeared from the cameras, leaving only the FED logo, without any reference to its lamentable origin. The FEDs, first built in 1934, are reasonably faithful copies of Leicas, for which reason they are the easiest imitations to pass off as the real thing; having erased any markings from the cover and baseplate and added the new logo, a Leica of whatever period desired is ready for sale, and at a far higher price than the original FED. There are differences, of course, beginning with the sound. The shutter of the cameras made in Wetzlar are proverbially silent; the FEDs are ten times louder. A second major difference is revealed by removing the lens: the small cam inside the camera that controls

What a beautiful Leica
But it's a big fake

Among the hundreds of fake Leicas, many have arrived directly from countries of Eastern Europe, in particular the former Soviet Union. This is an imaginative reproduction of a Schnitt, a cut-away model in which the functioning of the mechanism is exposed, which Leitz made for learning purposes. In this case, the forger went a little too far, covering the interior with red cloth and using an ocher varnish to make various details stand out. On the lens cap, instead of the usual Leica name he wrote the name of the customer, the "Berlin Academy of Military Doctors." And what would they have done with it?

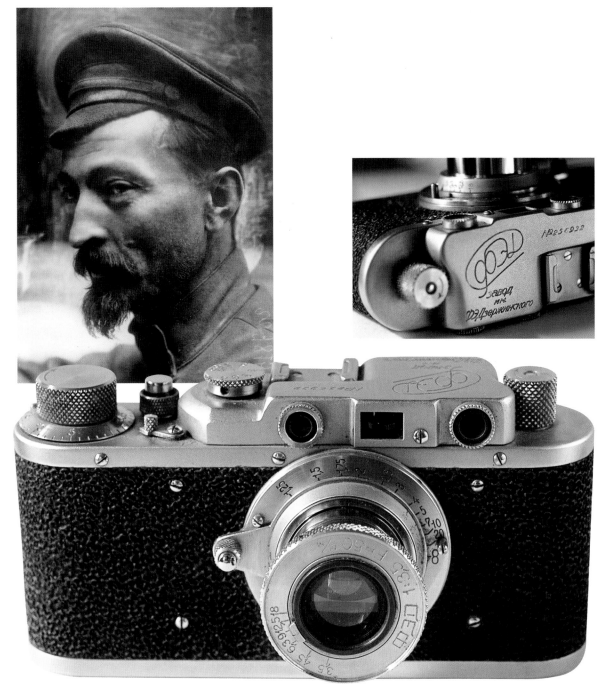

**Dedicated
to Dzerzhinsky**

Left, the top plate of a FED,
with the inscription in honor
of Felix Edmundovich
Dzerzhinsky, head of the
secret police (to the side).

the rangefinder is round in the Leica and blunt on the FED. Then there is the fact that when the FED is loaded, the shutter speed button turns but then returns to its initial position; not so on the Leica. The film advance is very smooth on the Leica, far rougher on the FED. Most telling of all is the central eyepiece of the rangefinder, which on the FED is square and fixed with a screw. There are other differences, and a trained eye has no trouble spotting them. As for the production, the serial numbers are direct references to the year of production. The camera shown here, for example, was part of a lot made on the occasion of a visit to the factory by Stalin. The current value of these cameras rarely exceeds 100 euros, less than one-fifth of the value of a Leica from the same period. After the war, in 1945, the Soviets appropriated the precision machinery of the Zeiss factory in Jena and transported it to the Soviet Union. Much of this machinery rusted in transit; what could be salvaged was put to work creating another copy, this time of the Contax, which became known as the Zorki in the USSR. In this case, the differences between the original and the copy are so great that there is little danger of encountering a Zorki being passed off as a Contax.

1945: the return to life and the rebirth of democracy

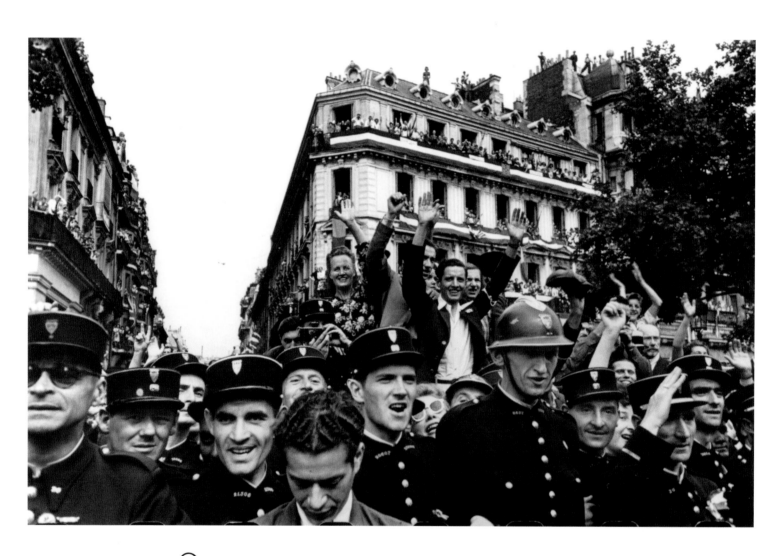

Joy and desperation

Above, immortalized by Robert Capa, a street celebration during the liberation of Paris, August 25, 1944. Opposite: Alfred Eisenstaedt, mother and daughter, survivors of the atomic bomb dropped by the United States on Hiroshima on August 6, 1945.

On May 2, 1945, after almost six years of war, Germany signed an unconditional surrender. Japan continued to fight until August, surrendering only after atomic bombs had been dropped on Hiroshima and Nagasaki, destroying the two cities and causing nearly 200,000 deaths. The two, contrasting images on these pages were chosen in memory of that period, which cut the century in two and began the long period of the cold war between the countries within the political-military sphere of the USSR and those allied with the United States. The first presents a scene from the enormous celebration during the liberation of Paris. It was taken by an almost incredulous Robert Capa, who survived

the Normandy landings and arrived in the French capital together with Ernest Hemingway, following the troops of Charles de Gaulle. As was his habit, Capa did not wait for the city to be liberated but arrived in time to follow the street fighting between the French and the German troops left behind to slow the Allied advance. The second image was taken by another great photographer, Alfred Eisenstaedt, who was among the first reporters to enter the defeated Japan. Against a background of total destruction are a mother and child, survivors of the atomic bomb dropped on the city of Hiroshima on August 6, 1945. According to some estimates as many as 79,000 Japanese died that day.

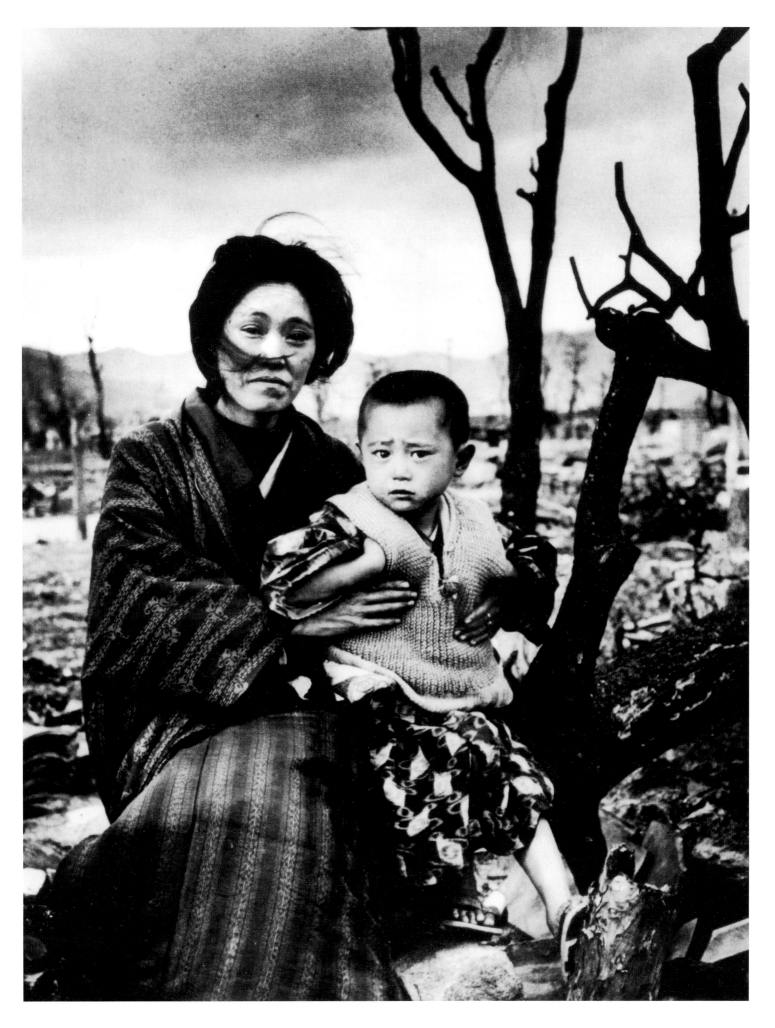

The difficult rebirth

How much was a Leica worth at the end of World War II? The price was set on the black market. The camera's official price was between 300 and 600 marks, but if you found someone who wanted it, you might get as much as 42,000. Which, at black market prices, would also buy 6,000 American cigarettes. If you found a farmer with a nicotine habit, your meals would be guaranteed for quite a while . . .

Life in postwar Germany went along that way, based on an economy of bartering. Even Wetzlar had been bombed and occupied by American forces. In the midst of disaster, the Leitz factory had not been damaged. Germany was in need of everything, including Leicas, and production started up again, first slowly then steadily. By the beginning of the 1950s Barnack's camera was again an object of desire. Europe was embracing the automobile, including the pleasure of Sunday outings, and everyone wanted to bring home an enduring souvenir. The age of images was making its start.

The unstoppable power of the system

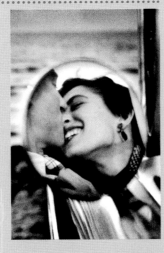

Elliott Erwitt, joy revealed

Mario De Biasi and the tough face of New York

Robert Doisneau, "Parisians I love you"

Postwar hardships
When a Leica was worth 6,000 cigarettes

Bombs on Wetzlar

Above, ruins of the nursery school of Wetzlar, destroyed during the Allied aerial bombardments of 1943–45.

Leitz centennial 1949

Right, centennial commemoration of the founding of Leitz in 1849.

Allied bombing had caused casualties (almost 400) even in Wetzlar, and 4,482 inhabitants were left homeless. The Leitz factory, however, escaped damage, and the American occupation of the city took place without bloodshed. Even so, the general climate was understandably depressed. Even the famously energetic Ernst Leitz II seemed to his workers to be listless, almost done in by the situation. There is an anecdote from that period worth recalling: a worker asked the aging businessman why he didn't intervene, at least do something. To which Leitz responded, "As long as my people go to sleep with fear, I'll behave in the same way."

The situation soon changed. The American administration had no desire to see the economic life of Germany stagnate, and all industrial sectors were soon made ready to start up again. In June Leitz returned to activity, with 1,569 active workers, a number that grew to more than 2,000 by the end of the year. Even so, there were serious economic difficulties to face. Nothing was available in Germany on the official market; everything had to pass through the black market. The Reichsmark, the coin of the Reich, was practically worthless. The situation changed radically throughout Germany on June 20, 1948, when the monetary reform took effect and the Reichsmark was replaced by the new Deutschemark. By then Leitz was in full activity, although still formally under control of the military administration. In 1949 Leitz celebrated, with great fanfare, the centennial of its founding and, unfortunately, had to grieve the death of one of the founding fathers of the Leica, Professor

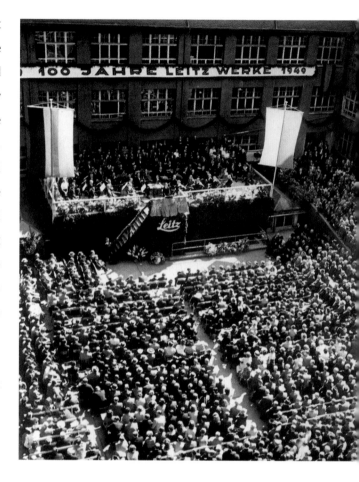

Max Berek, who had designed the lens for the camera invented by Oskar Barnack.

June 15, 1951, marked the end of an epoch in the history of the German company with the death of Ernst Leitz II. On March 1 of that year his eightieth birthday had been the cause for an enormous celebration. On the day of his funeral thousands of citizens gathered in the cathedral of Wetzlar and in the square nearby to pay homage to the man who had made Wetzlar the pride of the German optics industry. The company passed into the hands of his son Ludwig Leitz II.

The Leica was still the camera of choice for reporters, and the fame of its quality and precision held fast throughout all of the next

The return to life

Left, the square in front of
the Leitz factory in 1958 at
the end of a work day. During
that period the workweek
included Saturday, until one
o'clock.

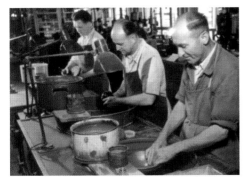

decade. Exportation to the American market
began again. In 1961 the millionth Leica was
manufactured, and the serial number 1,000,001
was sent to the famous American photographer
Alfred Eisenstaedt, whose picture of Hiroshima
appears on the preceding page. The 1960s marked
both the height of the Leica system and the onset
of its difficulties. Japanese manufacturers were
making strong inroads on the world market,
offering cameras at far lower prices than those of
the German cameras and at an optical-mechanical
quality that was often their equal. Leitz
responded, in 1964, with its first reflex camera.

The discovery of mobility

Often overlooked as a factor behind the surge in
amateur photography is the advent of large-scale
motorization. Around the mid-1950s all across Europe
the move was made from the bicycle to the scooter
(below, ad for the Citroën 2CV) to the economy car.
Sunday became the day for an outing, perhaps a
picnic in the country. Thus also the occasion to take
pictures of the family and new settings.

Maintaining quality

Above, three steps in the
making of lenses at Leitz,
from the preparation of the
molds, checking the glass,
and the final cleaning.

The success is repeated: the power of the system

Since 1932, one of the reasons behind Leica's success had been its use of interchangeable lenses, making it possible to always have the right framing at the right moment. Leitz lenses had high-quality optics of a moderate weight, making them readily portable. Leitz always believed that lenses should be judged by results achieved and not merely on the basis of laboratory tests. What counted most was not just sheer image definition, meaning the capacity to transfer to the film the highest number of possible "points" of the subject being photographed, but rather the "plasticity" of the photo, its three dimensionality. This quality was not measurable, although it was tangible. Other manufacturers rejected this Leitz theory outright, holding that if a lens was the best according to laboratory tests, there was nothing left to discuss. And sometimes Leitz lenses were not the best. Even so, the fact remains that Leica fans have always defended the superiority of Leitz lenses, particularly in situations of poor lighting. One thing can be said: an image taken with the rangefinder Leica, in particular color transparencies of low light sensitivity (25–50 ISO), can be recognized when compared with those taken with Japanese cameras. First of all there is the light: Leica lenses tend toward coolness and do not add unnatural warmth to colors. There is then the sharpness and depth of the image, with the various planes maintained intact and not "squashed," thus preserving the details of the image even in the less illuminated areas, including the rendering of flesh tones in portraits. There is thus a good reason why the Leica world is composed in part of lovers of pretty images. If the strength of a photograph is in the

Unrivaled

Above, a pamphlet from 1952 illustrating the power of the "Leica system." The text begins, "The demanding photographer will get a Leica."

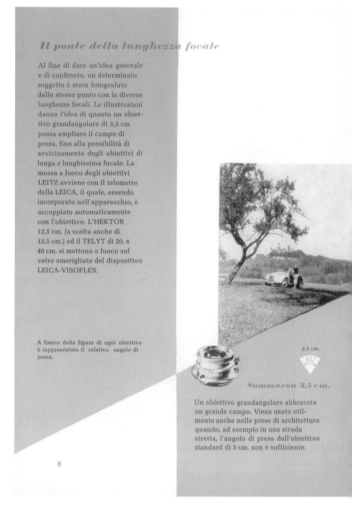

combination of light and framing, a less than successful photo can be saved by perfect technical execution and by the spectacular rendering of detail and color. In any case, in the 1950s the availability of lenses for the Leica stabilized; another record was made on October 24, 1952, when the millionth lens, an ultraluminous 50mm Summarit f/1.5. To show the flexibility of its photographic system Leica published numerous booklets giving technical descriptions of the uses of the various lenses. The one shown here is from 1954 and was made for the Italian market. It demonstrates how a photographer

Elmar 5 cm.
Summicron 5 cm.
Summarit 5 cm.

Gli obiettivi di focale normale della LEICA si distinguono soltanto per la loro diversa luminosità. Il loro angolo di presa è calcolato in modo da ottenere una favorevole prospettiva per prese normali con una grande nitidezza anche in profondità.

Elmar 9 cm.
Summarex 8,5 cm.

La quasi doppia lunghezza focale rispetto agli obiettivi standard di 5 cm., dà dal medesimo punto di presa, una quasi doppia grandezza del soggetto. La prospettiva particolarmente favorevole per presa da brevi distanze (ad esempio nei ritratti) corregge errori di distorsione e permette di ingrandire il soggetto nel fotogramma.

9

Hektor 12,5 cm.
Hektor 13,5 cm.

Ingrandimento, in rapporto agli obiettivi di 5 cm., rispettivamente di 2,5 e di 2,7 volte. L'effetto "ravvicinante" delle grandi lunghezze focali costituisce il segreto di molte fotografie sportive e di attualità, che riproducono molto ingranditi nel fotogramma soggetti non avvicinabili. Particolarmente usati nella fotografia panoramica, in questo caso l'HEKTOR dà delle prospettive sorprendenti ed efficaci. Un altro campo interessante è costituito dalle fotografie ravvicinate (vedi pag. 23).

Telyt 20 cm.
Telyt 40 cm.

Questi due obiettivi sono degli autentici teleobiettivi e si distinguono perciò per la costruzione di dimensioni relativamente ridotte. L'ingrandimento in rapporto alle focali normali di 5 cm. è rispettivamente di 4 e 8 volte. La grande lunghezza focale ravvicina (fortemente ingranditi) soggetti molto lontani. Come con un fucile a cannocchiale, il soggetto può essere osservato e colto. (Messa a fuoco soltanto sul vetro smerigliato del dispositivo LEICA-VISOFLEX).

10

can take pictures of the same subject without changing position simply by using different lenses, from the wide-angle to the telephoto. It must be noted that the Leica rangefinder system succeeded in focusing up to a focal length of 135mm. For the longer lenses an accessory was built, the Visoflex, a reflex housing containing a ground-glass focusing screen, which is mounted between the lens and the camera. It permitted the use of longer lenses on the Leica, such as the 200mm and 400mm, counting on the proverbial ease and softness of the shutter (meaning absence of vibrations).

Magnum
a cooperative of photographers

Robert Capa had been thinking about it for more than a decade, ever since his days as an exile in Paris during the 1930s, when he'd made friends with two other up-and-coming photographers, Henri Cartier-Bresson and David "Chim" Seymour. Only in April of 1947, at the restaurant of the Museum of Modern Art in New York, did it finally become a reality. The idea was both simple and groundbreaking: photographers should own the copyright to their work, in that way protecting themselves from exploitation by editors. Simply put, Capa had invented the idea of getting royalties for the use of images. At lunch at MoMa, amid many glasses of Champagne, Magnum Photos was born, the first photographers' cooperative. Aside from Capa, Seymour, and Cartier-Bresson, its founding members included George Rodger (who like Capa had participated in the war against the Nazis), Gisèle Freund, Maria Eisner (former director of the Alliance agency), Bill Vandivert (photographer for *Life*) and his wife, Rita. Each associate founder contributed $400 to the agency, which was registered on May 22. Seymour was to cover Europe, Cartier-Bresson India and the Far East, Roger Africa and the Middle East, Vandivert was to direct the New York office, and Maria Eisner the office in Paris. Capa was left to work at large, with no fixed location. Magnum was to get 40 percent of the payment to a photographer for work received through the agency, 30 percent of earnings for work obtained by the photographers themselves, and 50 percent of earnings from the sale of images. Magnum's first client was the *Ladies' Home Journal*, which asked for reporting on families around the world.

Family portrait

Annual Magnum meeting in Paris during the 1950s. Front row: Inge Bondi, John G. Morris, Barbara Miller, Cornell Capa, René Burri, Erich Lessing; between rows: Michael Chevalier; back row: Elliott Erwitt, Henri Cartier-Bresson, Erich Hartmann, Rosellina Bischof Burri, Inge Morath, Kryn Taconis, Ernst Haas, and Brian Brake.

Elliott Erwitt, joy revealed

"Rear View Mirror" was taken in 1955 on a California beach by one of the most entertaining Leica photographers, Elliott Erwitt, born in France (Paris, 1928) of Russian descent (his parents had emigrated from the Soviet Union). Erwitt moved to the United States in 1939 and attended a photography school in Los Angeles until 1944. Sent to Europe for "Life" magazine he met Robert Capa, who introduced him to the Magnum agency in 1953, of which he became a member in 1954. We have chosen this image as an outstanding example of the joie de vivre that characterized the postwar period, most of all in the 1950s, when Europe, having recuperated from the war, rediscovered the joys of having fun and being in love. It appeared on the front of the jacket of Erwitt's most memorable book, Personal Exposures.

Rear View Mirror, 1955.

Mario De Biasi, tough New York

Bitter America, New York, 1955.

In February 1955, when he boarded the ship "Cristoforo Colombo" en route
to New York, Mario De Biasi (born in 1923) had only recently become a
professional photographer. On his arrival in New York De Biasi found himself
in a difficult situation: he spoke little English, had trouble making himself
understood, and had to stay in a cheap hotel. He had his courage, however,
and his Leica around his neck, and he set off to wander the streets. He took
pictures of the down-and-out along with women in mink, he shot skyscrapers
and the bright lights of avenues along with black children in Harlem. The
result was a portrait of New York that revealed the city's sharp social contrasts,
an image completely at odds with the pristine, sparkling image so popular in
Europe. The Italian journalist Camilla Cederna wrote, "Through De Biasi, the
greatest port city in the world reveals a fascination until now unknown."

New York Skyline, with the Empire State Building in the Center, 1955.

94

Piergiorgio Branzi, heartfelt Moscow

Early in the 1960s Enzo Biagi, director of the Italian RAI television news agency, needed a new correspondent to cover the capital city of the Soviet Union. He chose Branzi, a professional journalist and, for about ten years, a dedicated amateur photographer. Thus he came to report on and witness the years after Stalin, the period of the "thaw," when a strong wind swept across the USSR. He also took pictures: in streets and squares, in schools and workers' clubs, he took pictures that present life in Moscow without apologies but also with the full awareness of someone who was there, who lived there and was trying to understand a

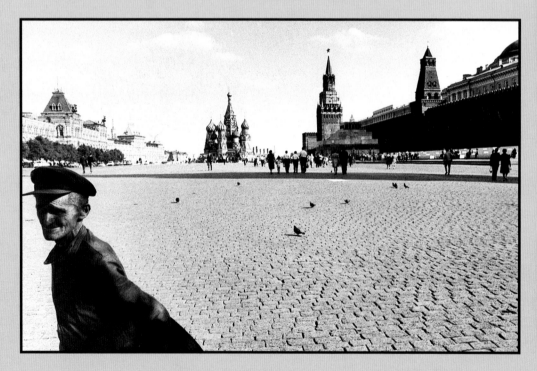

world, culture, and ideology so different from those of the West. His images reveal a society suffering from the overly rigid application of socialism. As the Italian poet Giuseppe Ungaretti once said, "You cannot put everything under state control. It's not realistic to expect a shave and haircut from the state."

Red Square, Moscow, 1962.

Lomonosov University Gymnasium, Moscow, 1962.

Robert Doisneau, "My Parisians"

"Le Baiser de l'Hotel de Ville" ("The Kiss at the Town Hall") is one of the best known and best loved pictures by the French photographer Robert Doisneau (1912–1994), who loved Paris and presented the city in a series of photographs that appear to be candid and spontaneous, even though Doisneau occasionally had friends or professionals pose for him. Such was the case with the famous "Baiser." Even if it was posed, however, the rush of the traffic and the reactions of the passersby give it the feel of a truly candid photograph, an image stolen from the swirl of the city just as the kiss itself was "stolen." Doisneau followed the principle that there is a spontaneity in the world around us and that what the photographer needs is the skill to see the moment he wants, frame it, and take it—all in a fraction of a second. In 1994 Doisneau wrote: "I've spent half a century walking the streets and sidewalks of Paris in all directions. As exercise it does not require exceptional physical strength. Paris, thank God, is not Los Angeles, and being a pedestrian is not a sign of indigence. I could never have taken great trips, the eyes of the locals would have embarrassed me. In Paris I am myself a local, part of the mass, part of the furnishings: a normal Frenchman, average height. Unusual features: none."

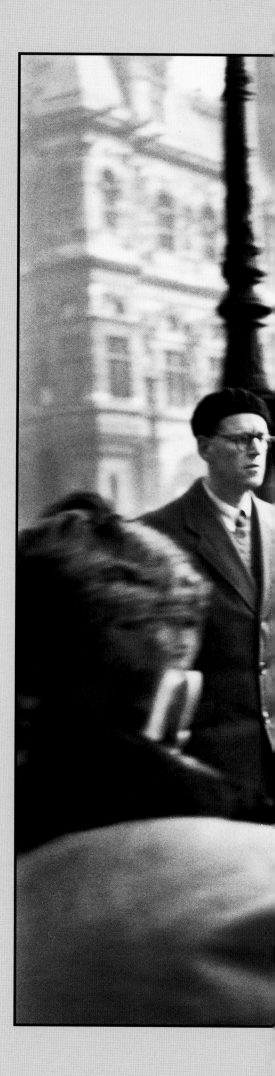

Le Baiser de l'Hotel de Ville, Paris, 1950.

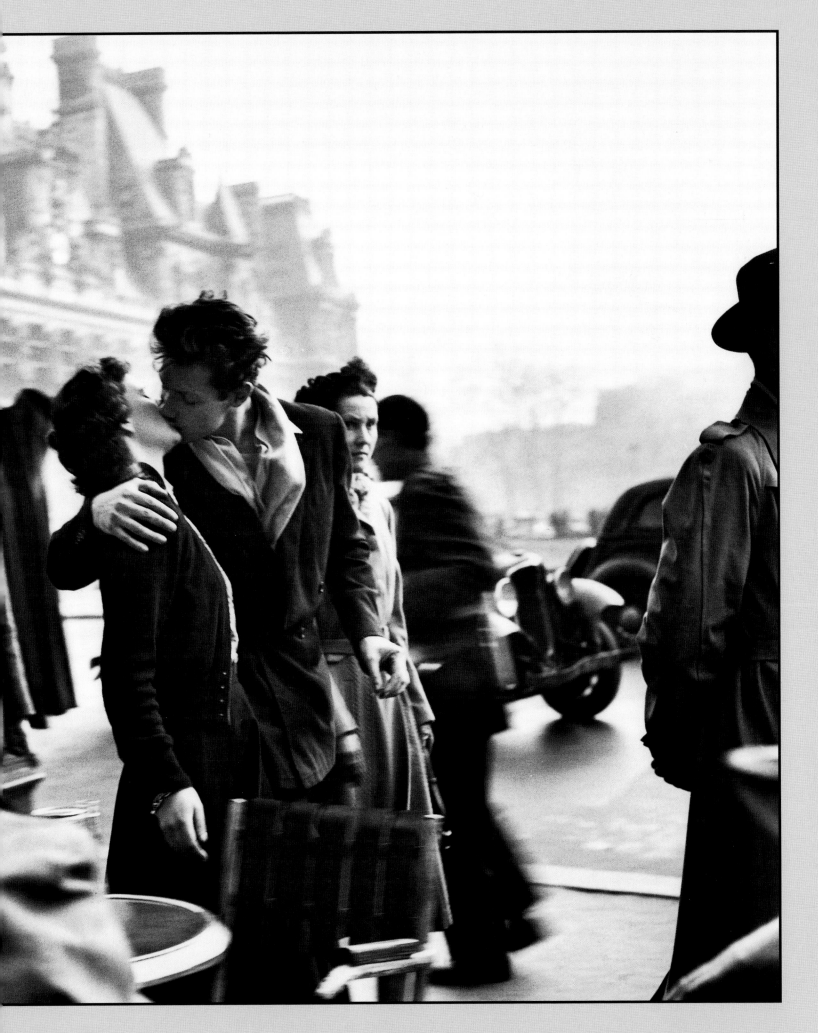

The turning point: the Leica M3

In the twenty-five years since the presentation of the Leica I at the Leipzig fair in 1925, Leitz had produced 795,000 cameras. By the end of the 1940s, the German manufacturer was thinking of a new camera to move past the limits that by then had become evident in the models with screwmount lenses, a design that had matured and did not offer room for further development. Competition from the Japanese was not yet strong, but it was getting there: Leitz could feel them breathing down its neck. The new design included the change in lens attachment from screwmount to the more rapid and secure bayonet, but most of all the new camera was to have a more powerful viewfinder with multiple framelines and automatic parallax correction, a coupled rangefinder, rapid film-advance lever (instead of a knob), and a single nonrotating dial for shutter speeds. It also could be fitted with a light meter coupled to an automatic flash that connected to the shutter-speed dial. All this, while maintaining an acceptable weight and size.

Technical data

Rarity grade:	●
Years of production:	1954-1968
Serial numbers:	700,000 to 1,206,999
Quantity produced:	225,294
Finish:	black and chrome
Lens:	interchangeable bayonet
Shutter:	focal plane
Viewfinder:	incorporated
Rangefinder:	incorporated
Self-timer:	yes
Strap lugs:	yes

Note: The production dates and serial numbers refer to all three types of M3 produced. The first type did not have the field-frame selector; the second and third types did.

Frame counter

A small improvement was made to the frame counter, inserted in a protective window. When the film was finished and rewound, it automatically reset itself.

Film-advance lever

The knob to advance the film was replaced by a more rapid and convenient lever at the base of the shutter release.

Reversing lever

The small lever that disengages the film for rewinding was moved from the top to the front of the camera.

Self-timer

Although not an important concern for professionals, the self-timer was improved on the M series, controlled by a lever on the front.

Lens release

The new bayonet attachment (three flanges) lenses were released by pressing a button near the lens.

Shutter speeds

All shutter speeds, slow and fast, were controlled by a dial on the top. The socket of the dial attached to a pin of the light meter, which fit into the accessory shoe.

Window rangefinder

Unlike preceding Leicas, the focusing of the rangefinder with its paired image was inside the viewfinder, eliminating the second paired eyepiece.

Rewind button

At the center of the rewind button were one or two red dots that turned to indicate the proper advance of the film when using the film-advance lever.

Viewfinder with frames

The new M series had a viewfinder with three framelines, with fields corresponding to the 50mm, 90mm, and 135mm, that were automatically selected according to the lens mounted. Parallax adjustment (compensation for the differing angles of view of the viewfinder and lens) was automatic.

New lenses

With the change to the bayonet attachment, new lenses were made with a rigid mount, but they were based on the earlier optical designs.

Frame selector

In 1955, a lever was added to the M that permitted the manual insertion of any field frame without having to change the lens.

Inge Morath, accidental photographer

The life of Inge Morath (1923–2002), born in Graz, Austria, to scientist parents, changed radically in 1951. Until then, she had given no thought to becoming a photographer, and for several years had been working as a journalist, first in Austria and then in Paris. In fact it was in Paris that she met Robert Capa, founder of Magnum. She began to write texts for the agency's photos, and in 1953, after her first attempts to take pictures on her own, Cartier-Bresson took her with him on a photojournalism trip to London. In 1955, she joined Magnum and began traveling a great deal, in Europe (the photo to the right, from a report on Ireland, was taken with a Leica M3 and 35mm Summicron f/2 lens), North Africa, and the Middle East. Morath soon became one of the most popular photographers in the international press. She moved to New York, and from there took off on trips that consolidated her fame: to the Soviet Union, beginning in 1965, and to the People's Republic of China, beginning in 1972. In the 1980s and 1990s, Morath continued to work on personal projects and commissions, winning many awards, including the Austrian State Prize for Photography, the Gold Medal of the National Art Club, and the Medal of Honor in Gold of Vienna. It was often said of her that she put as much feeling into her pictures of anonymous people as she did into her pictures of celebrities. To commemorate her work we have put the emphasis on ordinary people, a moment of life in postwar Ireland.

Puck Fair, Killorglin, Ireland, 1954.

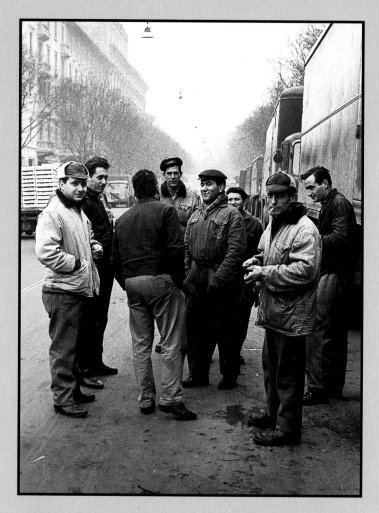

Ernesto Fantozzi, Milan caput mundi

"Out of passion, because I liked it, I decided to take photographs, but I have never made it my work, it has never become my career. Which is the way I wanted it. I could never have taken photographs on commission." Ernesto Fantozzi is an atypical soul in the world of photography, as is clear from his decision to keep the pleasure of photography separate from the necessity to work. Born in Milan, he has made of Milan what Doisneau made of Paris, a timeless setting in which humanity pauses for an instant before passing on into history. Fantozzi fell in love with photography during World War II; his mother sometimes left him in the care of a neighbor who, to keep him busy, gave him copies of "Signal" to look at. As Fantozzi says, "I spent hours studying the pictures, and since I could not read the captions I learned to read the pictures, to understand their contents."

In 1957 he was given his first camera, a 35mm Kodak, and in 1958 he joined the Circolo Fotografico Milanese. In 1966, Fantozzi founded Gruppo 66, an open association of professional and amateur photographers that met once a month in the cellar of a bar in the old section of the city, in Via Sant'Orsola. As Fantozzi recalls, "Everyone brought their photos, and we spread them out on the green baize of the billiard tables and talked about them. Only those that met with unanimous approval were cataloged and put in the archives." Fantozzi chose to photograph Milan, its people, its hinterland. As Doisneau did with Paris. "I wanted the city and rejected the exotic. Most of all I wanted to tell stories of the lives of ordinary people through pictures that, as I knew, would not have interested any magazine. These photographs were born from the desire to show moments of daily life that, except to those with attentive and sensitive eyes, may not seem to have any particular relevance in the present, but from the historical perspective become tiles in a mosaic. I have never tried to show a figure but rather a person, with the potential to become a celebrity."

Milan, 1965.

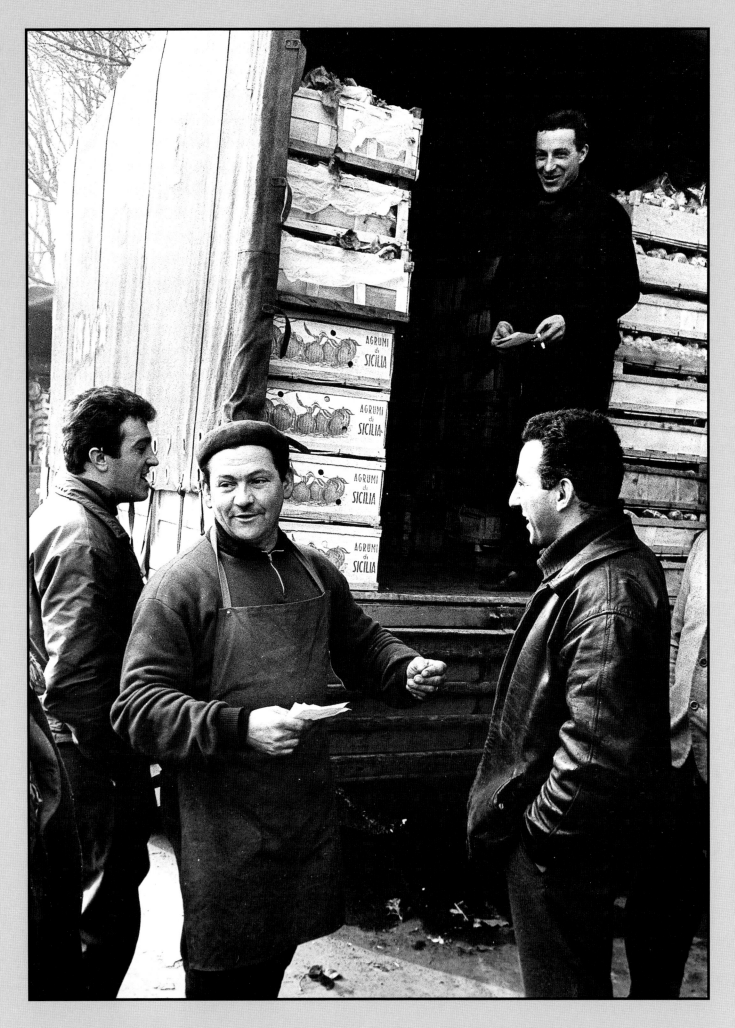

Surprises: Yul Brynner, actor and great photographer

Not only actors

Right, the Spanish painter Salvador Dali, photographed by Brynner in his Spanish home, with Jacqueline Thion de la Chaume Brynner, 1970 (Victoria Brynner, *Yul Brynner: Photographer*, Harry N. Abrams, New York, 1996).

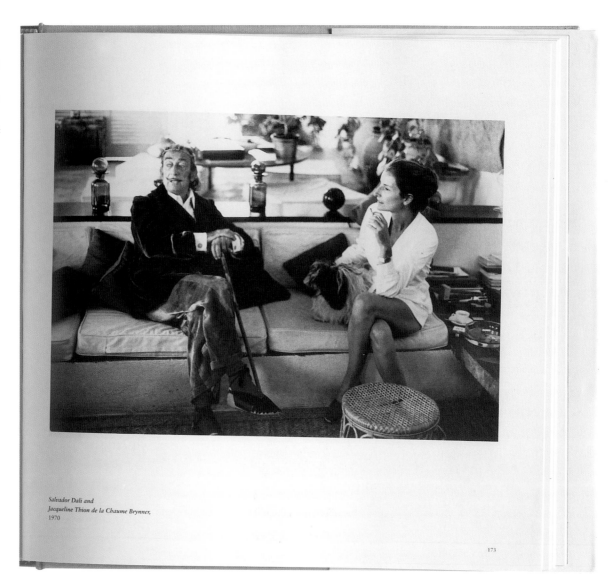

Salvador Dali and Jacqueline Thion de la Chaume Brynner, 1970

173

The postwar years were a glorious period for Leica, which was not only a precision instrument for professional photographers but also the camera of choice for amateurs, including members of the social elite who testified to their happy existence using the best possible technical means. Among the many amateur photographers was Yul Brynner, the actor who died so prematurely in 1985. With technical skill and, all things considered, a good eye, Brynner took hundreds of pictures of his family and friends, along with members of the beautiful people of Hollywood, from Ingrid Bergman to Elizabeth Taylor, from Sophia Loren to Vanessa Redgrave. Brynner's friends included artists from outside the jet set, such as Salvador Dali and Jean Cocteau, Charles Aznavour and Amanda Lear. His daughter Victoria, who was only 22 years old at his death, recalled his interest in photography: "My father shared his

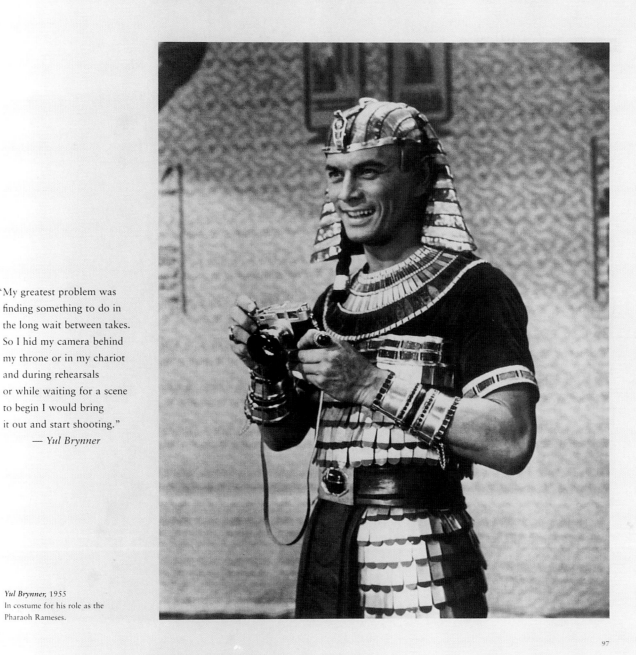

"My greatest problem was finding something to do in the long wait between takes. So I hid my camera behind my throne or in my chariot and during rehearsals or while waiting for a scene to begin I would bring it out and start shooting."
— *Yul Brynner*

Yul Brynner, 1955
In costume for his role as the
Pharaoh Rameses.

97

interest in photography with my mother and his close friends, the photographers Ernst Haas, Inge Morath, and John Bryson. . . . Over the years, my mother created a series of magnificent photo albums filled with their work. . . . His portraits are filled with love and a real sense of intimacy . . . Although he had many opportunities to publish a collection of his photographs, and spoke often of doing so, he never took the final step. In the process of assembling and organizing my father's work for this book, I have shown these photographs and spoken about them to many of his friends and colleagues, as well as to the members of my family. In the course of these conversations, I was greatly touched by how much people respected him and loved him. One person after another mentioned not only his talent and versatility, but also his generosity of spirit."

Film and Leica

Above, Yul Brynner in costume on the set of *The Ten Commandments,* in 1955, holding a Leica M3 (*Yul Brynner: Photographer,* Harry N. Abrams, New York, 1996).

Apotheosis and pride

It is a statement of fact, without exaggeration. The Leica system, consolidated in the second half of the 1950s as the most precise and reliable, reached its apotheosis, its true perfection, in the next decade, when it was recognized as the ideal choice for photojournalism, snapshots, and action pictures in general. This was the case despite the arrival on the market of the Japanese single-lens reflex cameras, which notably reduced the commercial maneuvering room available to Leitz. As unlikely as it might seem today, the factor behind the continued success of the rangefinder Leica was its viewfinder with the framelines. Unlike the view with a reflex camera, in which one sees only what is framed (and there is that split-second blackout period between one picture and the next, which prevents the photographer from following the scene), in the Leica one sees more than what one photographs, the entire scene is always present, and there are no dark moments between one photo and the next. Also important was the Leica viewfinder, always luminous, in any condition of light, making it possible for the photographer to "sense" what was happening. Those who use a Leica "know" that all this is true, Those who discover it, become aware of it very soon.

The special series

The M3 revolution

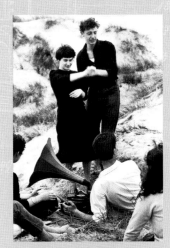

The return to journalism

The figures, the myth

Ladies and gentlemen, Her Majesty the Leica

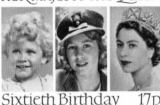

Royal aplomb

Above, the stamps issued
for the sixtieth birthday of
Elizabeth II. In one stamp
the queen is shown holding
a Leica M3.

Among the many more or less noble hobbies that have interested the members of Great Britain's royal family—and that have therefore attracted the scrutiny of the popular press—is photography. Indeed, the royals have shown a kind of passion for it. Queen Elizabeth II was no exception; in 1958 Leitz gave her a Leica M3 (num. 919,000) and in 1965 a Leicaflex, both cameras bearing the royal initials on the body of the camera and on the case. Such was Elizabeth's passion for photography that when selecting images to be used for a series of stamps

giving cameras to illustrious people and politicians dates back to 1925, the year the first Leica went on the market. As we have seen, num. 280 was given to Count Zeppelin, and num. 10,000 to the dirigible commandant Hugo Eckener. This custom, which had obvious promotional values, continued through the coming years. In 1934, Leopold Mannes and Leopold Godowsky were each given a Leica III (nums. 150,000 and 175,000) as an award for having invented Kodachrome, the first quality color film. In 1935, photographer Paul Wolff received a IIIa, num. 200,000. In 1941 Gustav Wilmanns and Wilhelm Schneider, inventors of Agfacolor, another excellent color film, were awarded with a Leica Standard (num. 300,000) and a Leica IIIb. The next year a IIIc went to the Desert Fox, Field Marshall Erwin Rommel. The tradition continued after the war. Aside from the millionth Leica produced, which was given to the founder, Ernst Leitz II, there was the Leica IIIf (num. 555,555) given to the Dalai Lama in 1951 and, that same year, the IIIf that went to the theologian, musician, and medical missionary Albert Schweitzer.

Another photographer to receive a Leica (an M3, num. 750,000) was the (by then) enormously famous Henri Cartier-Bresson, in 1955. The list is long and extends to recent times: among the many political figures are the German chancellor Konrad Adenauer (given an M3, num. 800,000, in 1956) and the Czech president Vaclav Havel (an M6, num. 2,500,000, in 2000).

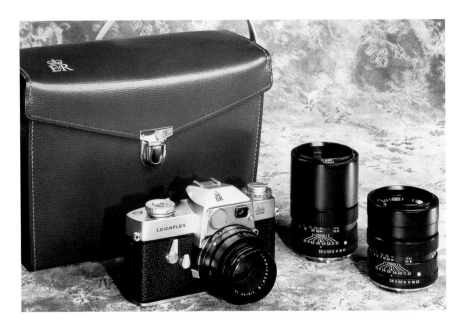

Noble initials

Above, the Leicaflex and
monogrammed case given to
Queen Elizabeth II in 1965 and,
opposite, Her Majesty the
Photographer.

dedicated to her and issued on the occasion of her sixtieth birthday, she chose one with the royal camera around her neck. The cameras given to the queen were by no means unusual events. In fact, the Leitz tradition of

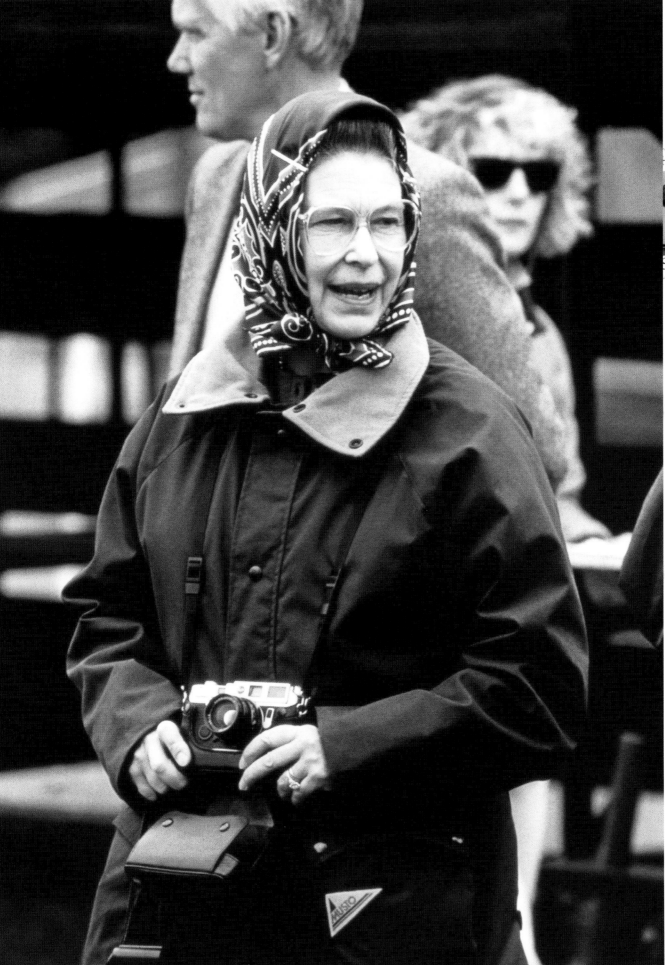

Leica M4

After the M3, which introduced to the Leica system framelines in the viewfinder that indicated the fields framed by the 50, 90, and 135mm lenses, Leitz presented, in 1957, the M2, which had a viewfinder with framelines for 35, 50, and 90mm lenses. Thus Leitz had to put in production two specific lenses, a 35mm for the M3 and a 135mm for the M2 with a particular optical attachment, called "spectacles" or "eyes," that converted the viewfinder to the correct framing. The method did not please users, who found the system of attachments less than practical. Thus in 1967 Leitz launched a camera that was the synthesis of the two preceding models, the M4, with framelines from 35 to 135mm. During this period competition from reflex cameras—which had the great advantage of not having limits on the use of lenses—was growing steadily stronger. Leitz took the necessary steps to respond, launching its first reflex camera, the Leicaflex, in 1964, with a light meter and shutter speed of 1/2000 of second.

New film-advance lever

Among the small innovations was the redesign of the film-advance lever, which was also given a black plastic tip.

Shutter speeds

Although shutters with speeds up to 1/2000 were on the market, the M4's fastest speed was 1/1000 of a second.

Self-timer

This camera, like the preceding series, has a self-timer controlled by a mechanical lever.

Lens release

To the left of the flange of the lens mount is a chrome button with a red dot: pressing it releases the lens.

More complete viewfinder

The framelines in the viewfinder include those for the wide-angle 35mm.

Rewind knob

The knurled button for rewinding the film was replaced by a knob mounted at an angle with a crank that unfolded for rewinding.

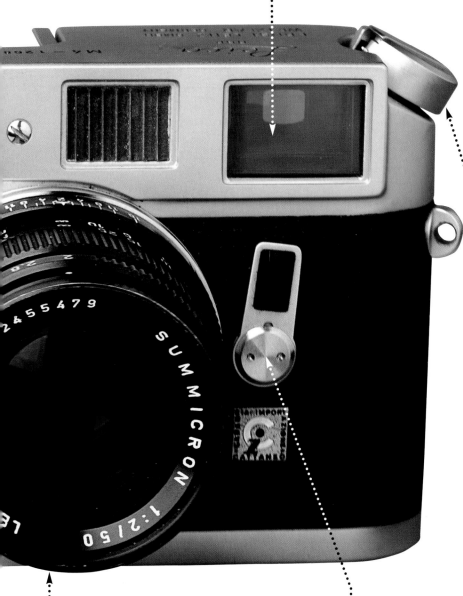

Interchangeable lenses

The Leica photographer can use a wide selection of lenses, with rapid attachment, that range from the medium-angle 35mm to the 135mm telephoto.

Frame selection

Like the other cameras in the M series, the M4 has a lever to select framelines without changing lens.

Technical data

Rarity grade:	●
Years of production:	1967-1975
Serial numbers:	1,175,001 to 1,443,170
Number produced:	58,904
Finish:	black and chrome
Lenses:	interchangeable
Shutter:	focal plane
Viewfinder:	incorporated
Telemeter:	coupled
Self-timer:	yes
Strap lugs:	yes

Note: The framelines included the 35, 50, 90, and 135mm lenses. The camera had a new rapid-load system that offered greater speed.

The Sixties:
from the last phonograph to the first man on the moon

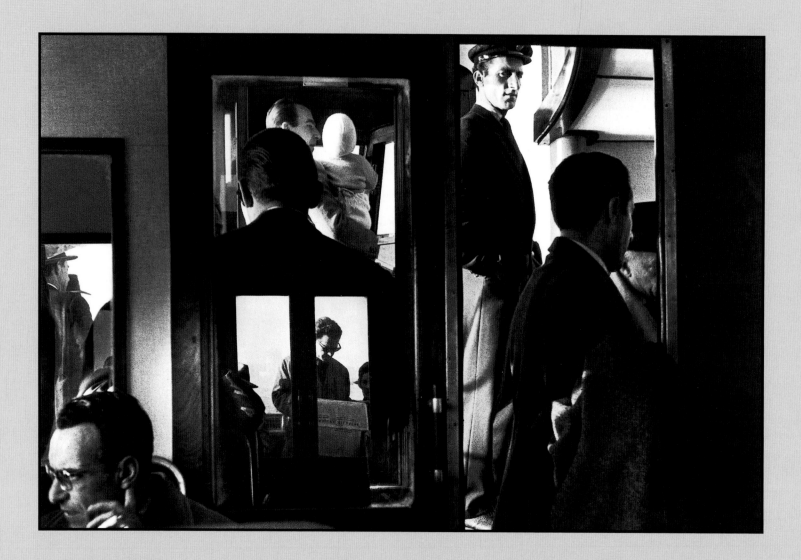

Gianni Berengo Gardin, the magic eye

Gianni Berengo Gardin is considered Italy's Henri Cartier-Bresson, and not only are the two men friends but the French photographer himself chose a photograph that Berengo Gardin had taken from a vaporetto ('water taxi') in Venice to serve as the emblem of his work in the new pantheon of French photography, the Cartier-Bresson Foundation. Born in 1930 at Santa Margherita Ligure, Berengo Gardin began taking pictures in 1954 and immediately fell in love with the Leica M, the only camera that let him look at reality with a different eye. In 1955 he was among the very first to take a specialization course at the Leica Akademie in Wetzlar. That was the beginning of a brilliant career that has led him to publish more than 190 books of photography. What these books have in common is a sense of humanity, of ordinary people caught in a great variety of situations, such as a dance to an old-time phonograph on the Lido of Venice, a bicycle outing among rice pickers in Vercelli, or the life of gypsies in Paris.

On a Vaporetto in Venice, 1960.

Picnic at the Lido of Venice, 1958.

Nearly ten years separate the two photos, but the difference is only of "class."
Top, picnic at Sotto il Monte, near Bergamo, Italy, 1969.

Above, a bite to eat between races at Ascot, Great Britain, 1977.

Boat on the Seine,
Paris, 1955.

Marc Riboud, Flower against the bayonets

In 1967 the United States was shaken by antiwar demonstrations. Marc Riboud covered one of the largest of these, involving hundreds of thousands of people at the Pentagon, symbol of U.S. military power. Without calling attention to himself he followed a 17-year-old girl, Jean-Rose, and using his Leica M4 was able to take a picture unobserved at the moment in which she confronted the raised bayonets of the soldiers with a flower. The image became a worldwide symbol of pacifism.

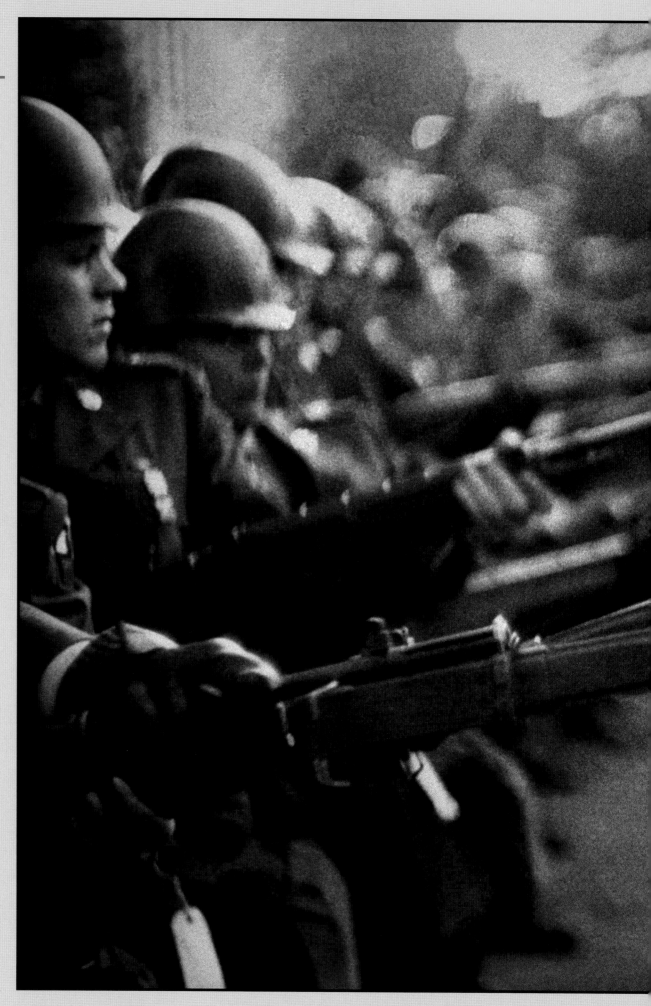

Flower against the Bayonets, 1967.

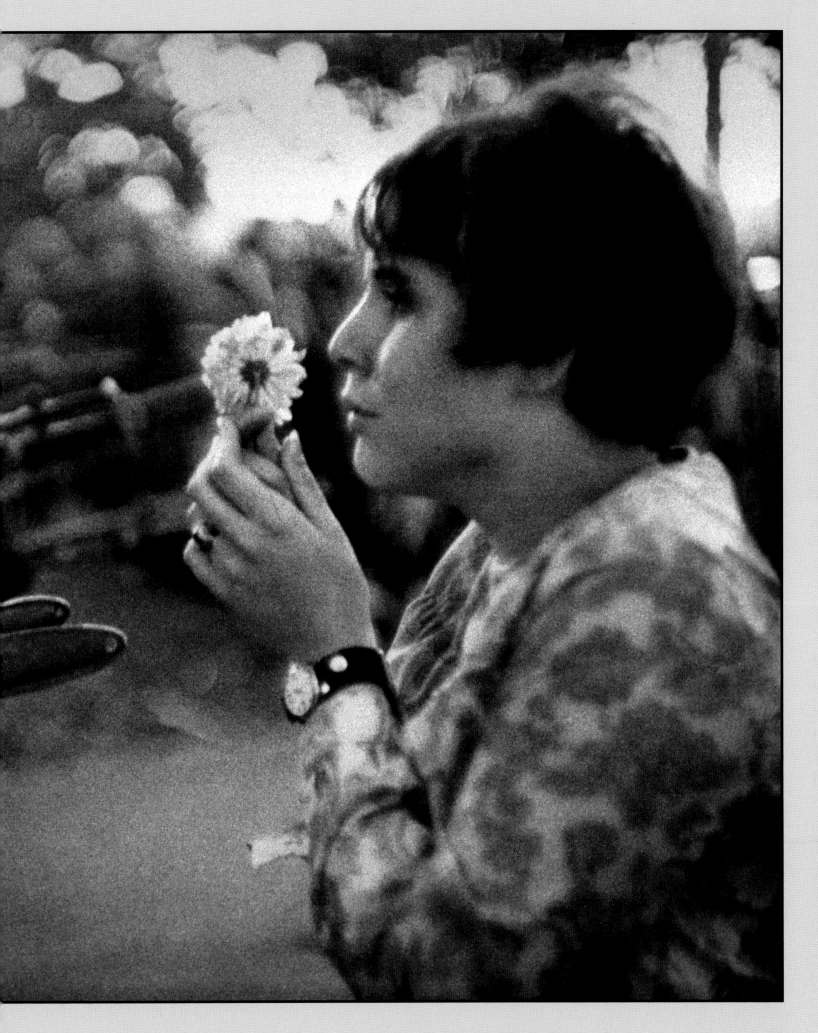

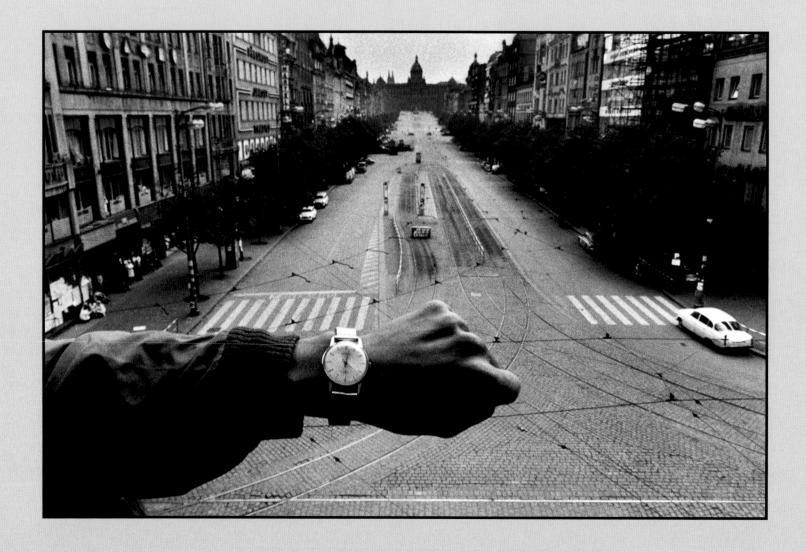

Joseph Koudelka, farewell to the Prague Spring

In August 1968, tanks of the Warsaw Pact, the military alliance of the Soviet Union and the countries of East Europe under its control, invaded Czechoslovakia and rolled into Prague. The reform government of Alexander Dubcek was deposed by force: thus ended the Prague Spring, those few months during which the communist regime of Czechoslovakia had sought to democratize the country's social and cultural life.

Koudelka, born in 1938 in a village of Moravia, documented those terrible days, the Soviet occupation and the episodes of protest and resistance, including armed resistance against the tanks bearing the hammer and sickle. Koudelka's photographic report testified to the entire world the end of Prague's liberal dream and earned him international recognition, including the prestigious Robert Capa Gold Medal. Koudelka succeeded in fleeing Prague and moved to Paris, where he lives today.

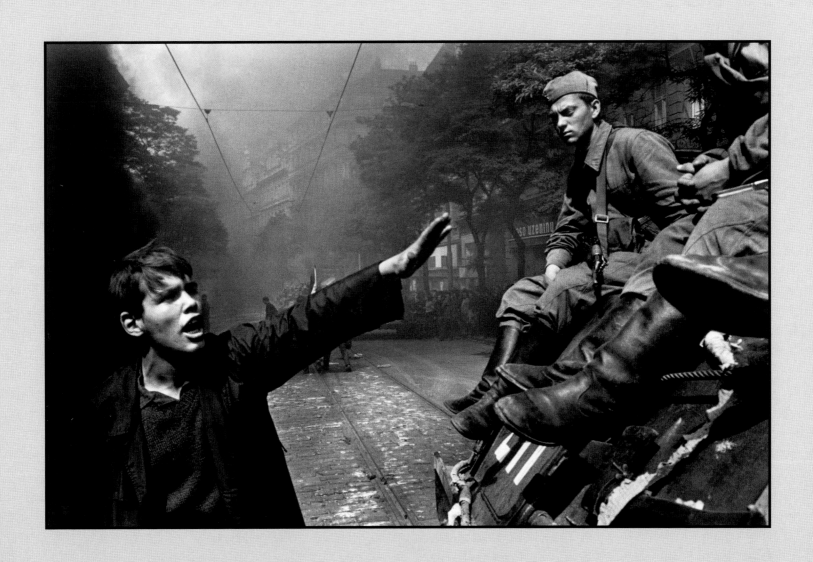

The Invasion of Prague, 1968.

The obligatory decision: Leicaflex

In 1964, in response to the advances made by Japanese-made reflex cameras, Leitz put its first reflex camera into production, the Leicaflex. The camera had a drawback in that the light meter did not read light through the lens but to its side, making it less accurate. Only three years later the Leicaflex SL appeared, with the light meter using photo cells inside the camera. The viewfinder is large and bright, and setting the correct exposure involves moving two pointers that appear on the right side, that of the built-in exposure meter and that of the aperture; when they line up (setting the speed and aperture) the exposure is correct.

In 1974 the Leicaflex SL2 arrived, structurally very similar to the preceding camera but with various technical improvements. The most important were a new, more sensitive and accurate light meter and a new mirror box with an even brighter viewscreen for focusing. However, Leitz chose a commercial policy that was to have unfortunate consequences. To compete with the Japanese, the decision was made to sell the body of the camera at a price below cost in the hope of making up the lost earnings through the sale of lenses. This was the German company's most important response to the competition from the East. Leitz later chose a different route, deciding to carve out a special niche for itself in the camera market by concentrating most of all on the M system, which had no competitors and was unbeatable in many situations, such as under conditions of poor lighting or where rapid action and discernment were more important than the greater versatility of single-lens reflex cameras.

Frame counter

Similar to those on the M series, the frame numbers appear beneath a small glass window.

Rapid shutter

The shutter of the reflex camera can be set to 1/2000 of a second. The synchronization with the flash is faster, 1/100 as opposed to the 1/50 of the rangefinder cameras.

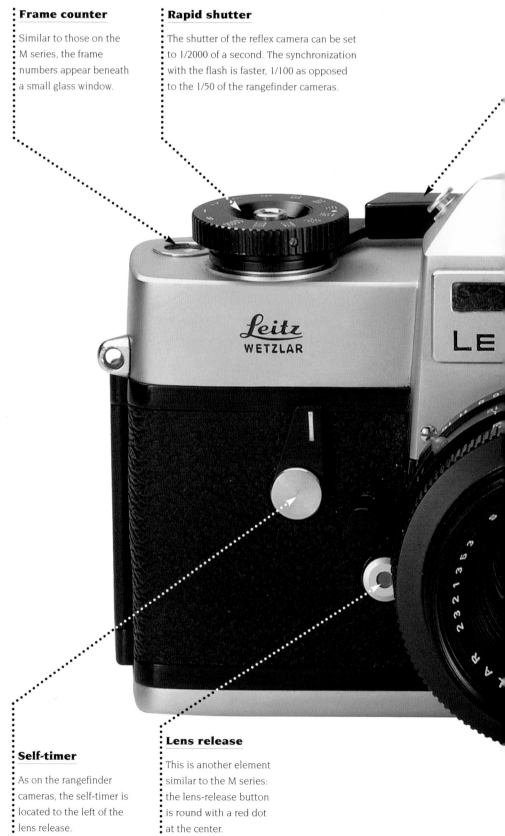

Self-timer

As on the rangefinder cameras, the self-timer is located to the left of the lens release.

Lens release

This is another element similar to the M series: the lens-release button is round with a red dot at the center.

Pentaprism finder

The mirror box is very sturdy, and the shutter speed and selected aperture are visible in the viewfinder. For improved vision in weak light, the viewfinder can be illuminated by pressing a button.

Rewind crank and film speed

To rewind the film there is an extendable crank; at the base of this is the film-speed selector with the numbers in white on black.

Technical data: Leicaflex SL2

Rarity grade:	●
Years of production:	1974-1976
Serial numbers:	1,369,801 to 1,446,000
Quantity produced:	23,750
Finish:	black and chrome
Lenses:	interchangeable
Shutter:	focal plane
Viewfinder:	reflex with a microprism screen
Light meter:	incorporated
Sensitivity:	8-6400 ASA
Self-timer:	yes

Camera body

The Leicaflex is one of the most robust reflex cameras to appear on the market and is constructed of the very best materials. The only weakness is the light meter, which can be damaged or thrown off by a blow.

Battery cover

The light meter of the Leicaflex runs on a battery located in a space on the front, protected by a cover.

Synchro-flash

On the front of the camera, protected by a lid, is the socket to connect a flash.

Jim Marshall,
The Beatles' last concert

On August 29, 1966, at Candlestick Park, San Francisco, the "Fab Four of Liverpool" played for the last time in public in the United States. Their fans did not know this yet, and several days were to pass before the announcement was made. Another four years were to pass before the breakup of the Beatles, and even that traumatic event did nothing to stem the tide of rock and roll, which flowed on through the 1960s, providing the background music to the period of youthful protests. The picture of the group farewell from Paul McCartney, John Lennon, Ringo Starr, and George Harrison was taken by one of the most famous photographers of pop stars, Jim Marshall, born in San Francisco in 1936 and active as a photographer since 1960.

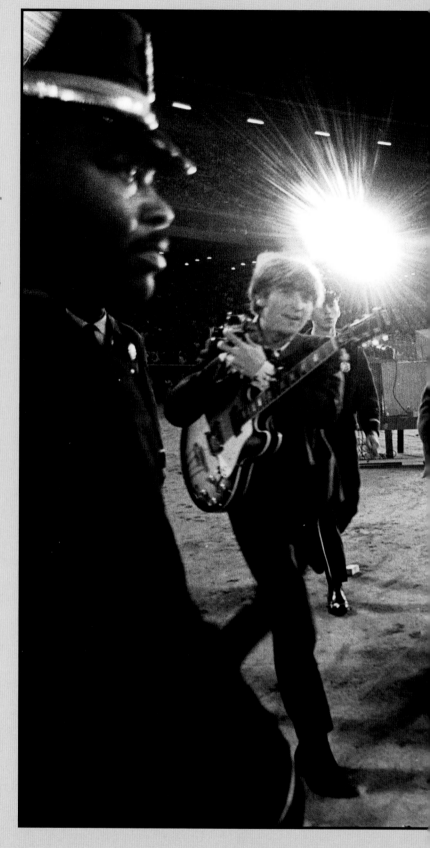

The Beatles' Last Concert, 1966.

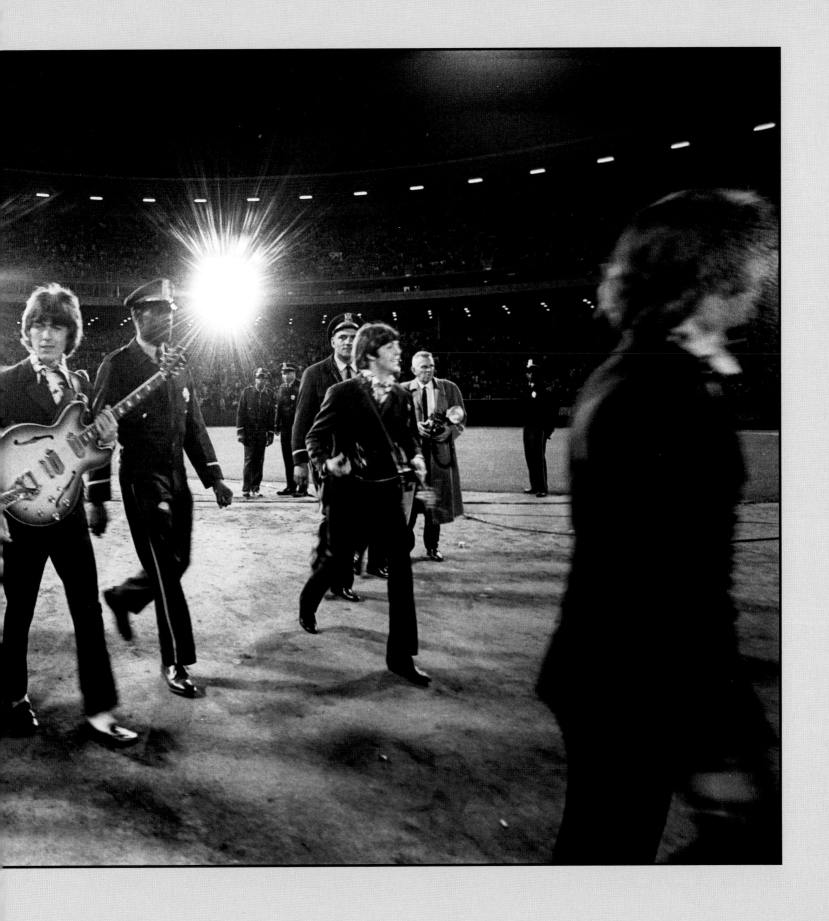

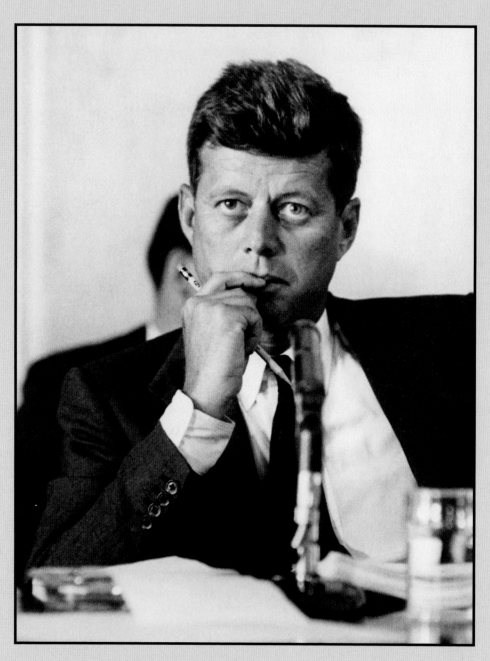

Fred J. Maroon, President JFK

This youthful portrait of John F. Kennedy dates to 1957, when he was a senator. Three years later he was elected president of the United States, and three years after that he was assassinated in Dallas, Texas. We have presented him together with Che Guevara not because both men met premature deaths but because Kennedy, following the failed Bay of Pigs landing of anti-Castro forces in 1963, dedicated himself to moving the world (including the difficult USSR of Khrushchev) toward peaceful coexistence. The photo was taken by Fred J. Maroon, reporter for "Life," "Look," and "Paris Match."

Alberto Diaz Gutierrez, Commandant Che Guevara

Opposite, one of the most striking and symbolic images of the youth movement of the 1960s and 1970s: the portrait of Ernesto "Che" Guevara, taken by Alberto Diaz Gutierrez, known as Korda, on March 6, 1960. The photo was taken with a Leica M2 and a 90mm medium telephoto lens. The original shot was horizontal, but during printing Korda realized that the vertical alignment gave more force to the commander of the Cuban revolutionaries. Thus the shot became only "Che."

Senator John F. Kennedy during the Senate Racket Committee Hearings, Washington, D.C., 1957.

Che Guevara, 1960.

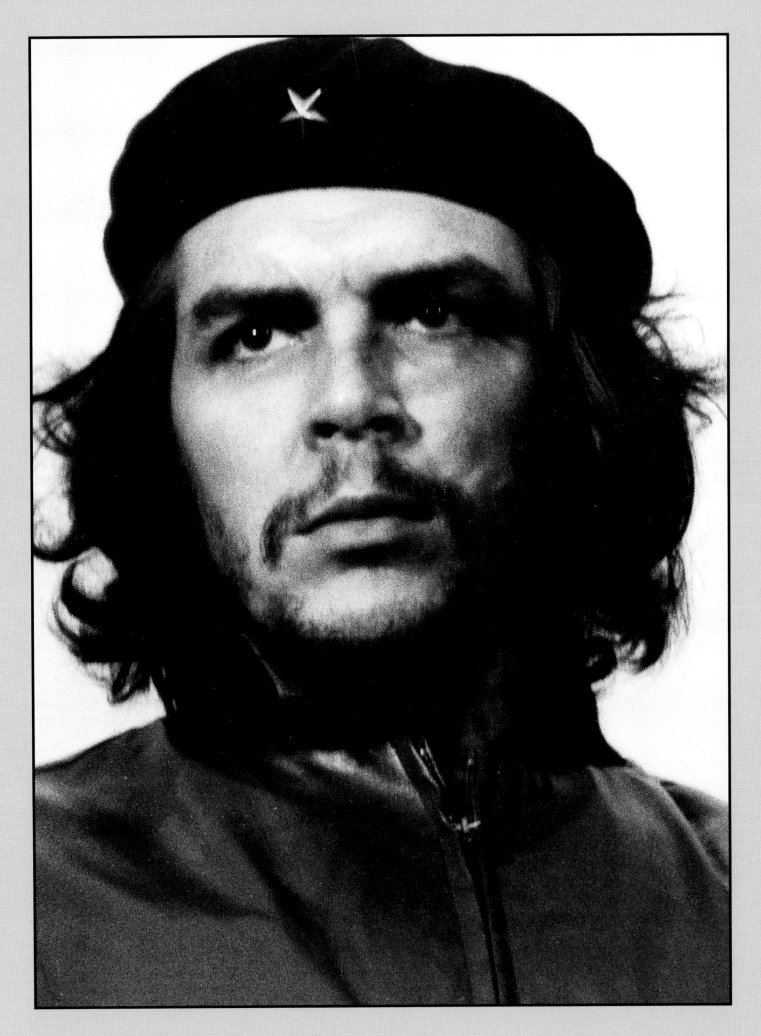

Leica M5
good ideas that ended badly

The short history of the M5 took place over a five-year period, from its release in 1971 to the suspension of its production in 1975. Its story is an example of how technical evolution alone cannot guarantee success. Over the course of the 1960s the Leica M rangefinder system had held up to competition from the more versatile Japanese reflex cameras, but it certainly seemed slower and less precise in the measurement of light. The external Leicameter showed excessive tolerance, especially for use with transparencies. Leitz planned to revitalize the M system by launching a new camera with an incorporated meter that read light through the lens (by means of a meter cell on an arm that swung in front of the shutter curtain). Unfortunately, the M5 was bigger and heavier than either the M3 or the M4, and the exposure system using a cadmium sulfide cell was not as fast as expected. The public continued to prefer the M4, and eventually Leitz discontinued the M5 and went ahead with the production of small variants (M4-2 and M4-P) until 1984, when the M6 and its incorporated silicon light meter (and its electronics) finally resolved the problem of exposure control.

In keeping with tradition

The shutter release has maintained its proverbial softness. Below, for the first time in the M series, there is a button for the speed selection, which stops at 1/2 second. Slower speeds, from 1 second to 30 seconds, are also indicated, but the shutter does not recognize them and they must be calculated with a watch and a remote shutter.

Hot shoe

Among the novelties, in addition to the attachments for the flash on the back of the body, the accessory shoe has a "hot shoe" to power the installed flash.

A special M5

This M5 is one of the somewhat rare cameras made in 1975 to commemorate the 50 years of Leica production.

Superluminous lens

During this period, Leitz continued the policy of offering increasingly luminous lenses for photography in prohibitive conditions. This lens is the first version of the Noctilux, with a maximum aperture of f/1.2 (later f/1).

Film-type selector

For the first time on an M series Leica, a selector for the type of film being used is on the cover of the camera.

The incorporated light meter of the M5 takes the measurement of luminosity through the lens.

Complete viewfinder

The viewfinder of the M5 has framelines for 35, 50, 90, and 135mm lenses. Unique among the M series, the speed is legible in the viewfinder, and by pairing two needles (one for speed, the other for aperture) the correct exposure is rapidly obtained.

Technical data

Rarity grade:	● ●
Years of production:	1971-1975
Serial numbers:	1,278,001 to 1,384,000
Quantity produced:	33,900
Finish:	black and chrome
Lens:	interchangeable
Shutter:	focal plane
Viewfinder:	direct
Rangefinder:	incorporated
Light meter:	internal and coupled
Strap lugs:	yes

Note: The framelines cover the 35, 50, 90, and 135mm lenses. The rewind crank is located in the base.

Strap lugs

Early cameras had lugs on only the short side, the right, so the camera would hang vertically. This arrangement did not meet with favor and a third lug was added to permit carrying the camera horizontally.

Frame-selector lever

The M5 included almost all the operative characteristics of the M system, including the ability to choose which lens to mount by selecting the framelines from a range running from 35 to 135mm.

Mario De Biasi, from the Earth to the Moon

On July 16, 1969, the "Apollo 11" space mission took the first humans to this planet's satellite. Neil Armstrong and Edwin E. Aldrin, Jr., along with Command Module Pilot Michael Collins, fulfilled the dream of humanity, the conquest of space.

Mario De Biasi, working for the Italian weekly "Epoca," was on hand at the Kennedy Space Center to follow the launch. His picture to the right portrays Armstrong and Aldrin in the cafeteria of NASA a few hours before their lift-off on the "Apollo" mission.

Below, the cover of the American weekly "Life" (to which the leading Magnum photographers contributed), dedicated to the historic lunar landing.

Armstrong and Aldrin Before Taking Off for the Moon, 1969.

Leni Riefenstahl, from the Moon to the Earth

On December 10, 1969, the German weekly "Stern" went a long way toward rehabilitating the great German photographer and director Leni Riefenstahl (1902-2003), who had been suffering a certain amount of ostracism because of her activities with the Nazi regime. "Stern" dedicated the cover and a large article to a report on the African population of the Nuba. Thus, in the same year as the moon landing the Western world discovered the marvelous life of an African tribe living the life of a thousand years ago, with neither money nor technology. In her book "The Last of the Nuba" Riefenstahl described her first encounter with the Nuba, in 1964: "A thousand, perhaps two thousand, people were moving about in the light of the setting sun on an open space thickly surrounded by trees. With their strange body-paint and fantastic adornment they looked like beings from another planet. Hundreds of spear-points danced against the red glow of the setting sun. In the middle of the crowd, larger and smaller circles had formed, inside which pairs of wrestlers were facing each other, making feints at each other or fighting or dancing, with the winner carried out of the ring shoulder-high . . . I was stunned, and did not know what to photograph first. Everything I saw was so unusual, so curious, and so immensely fascinating."

From here to eternity

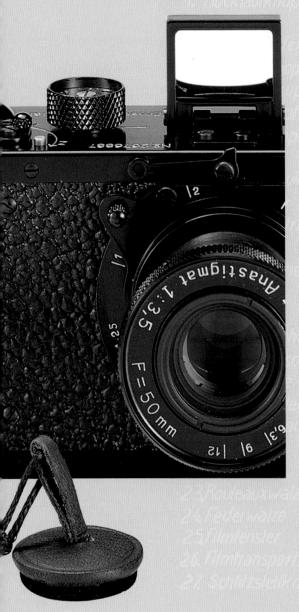

The approach of the future is always a disquieting reality. For a good reason: even the period we are living in demands to be judged and understood, is ready to make its way into history. The situation calls for a certain amount of discretion since looking back on the twentieth century almost all the events seem important. In this last chapter we have decided to hold tight to the theme that has brought us here: the representation of a century through the life of people, rich and poor, in peace and in war, West and East . . . which is also the reason why, despite all the changes in style related to the chaotic pace of technology, the Leica M, with its viewfinder with framelines, continues to hold its place. The Leica is the only camera that puts you down in the middle of the situation, that asks you to see the world from close up—just as Robert Capa held that war, to be described, should be photographed with a wide-angle lens. The idea is valid not only for war but for any social event. It is no mere coincidence that in the year 2000 Leica presented a new edition of the O-Series, the 1914 prototype with which Barnack took the first pictures.

And this was not a camera to put in a glass case. Today, as in the past, it is a camera to put around your neck and use to take pictures.

The end of the USSR

The rich West

Famine, war

**2000: Leica
enters the new century**

Return to the origins:
the revenge of the mechanical

Ambient light

Opposite, a photograph by
Vanni Calanca, president of
the Italian Gruppo
Fotografico Leica. This is a
perfect example of what is
meant by a photo taken in
ambient light (without a
flash) using a Leica M.

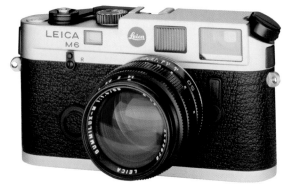

A small revolution

Above, the Leica M6,
presented in 1984. Inside
the body of the camera is
a silicon light meter that
is coupled to both the
shutter speed and the
aperture.
Production of the M6 ended
in 2002, with the arrival of
the M7, the first Leica M
with the light meter that
gives priority to the aperture.

Early in the 1980s Leitz made some courageous decisions. With the Leitz heirs no longer in control, a share of capital was put on the market (acquired by a Swiss company), and the direction of the company was taken over by new management, which put emphasis on research and development in the field of photography. In 1988 the Leitz logo was abandoned, keeping only that of Leica, a much more resonant trademark name among both amateurs and professionals. During this period the headquarters was moved from Wetzlar to Solms, a few kilometers away. The new building, low and white, stands on a street named for Oskar Barnack. By then, the photography market was dominated by the Japanese. Leica did have three important groups of clients, however: professionals in need of high-quality instruments, collectors all over the world eager to buy anything bearing the Leica name, and the more demanding amateur photographers, who take pictures for pleasure but want the highest technical results. In terms of improving cameras to bear up against the Japanese competition, a small but decisive step was taken to enable the M system to make its way into the next century. This was the Leica M6, presented at the 1984 Photokina fair, the most important European photography fair. Using the body of the M4, it has an electronic silicon-diode light meter mounted inside the body of the camera that measures the light reflected off a white disk

serigraphed on the shutter curtain. In the viewfinder two diode pointers indicate the settings for the diaphragm and the shutter speed, the correct setting indicated when the two diodes are lit at the same time. The light meter is activated by applying light pressure to the shutter-release button and it shuts off automatically after a few seconds to avoid running down the two batteries, which are held in a small space on the front, in the position once occupied by the self-timer lever. This is the first Leica to blend the electronic and the mechanical. Simple and intuitive, the new light-meter system greatly accelerates the photographer's response to variations in light conditions. Except for the diodes, the viewfinder is exactly the same as in the earlier design, the M4P, with framelines for lenses from 28mm to 135mm; the shutter is the classic all-mechanical Leica shutter, thus making it possible to take pictures even without the batteries.

Under the flange, toward the inside of the opening, is an opaque black ring that protects the photoelectric cell of the light meter from possible reflections; it has proven effective also in terms of the film, acting like an additional hood behind the lens. As for drawbacks, when taking pictures with an M6 one must remember that the image within the framelines is calculated on the minimum focal distance and that when framing a subject at infinity the visible image will be slightly larger than the area marked off by the framelines. For example, with a 50mm lens focusing at infinity, 15 percent of the scene is lost, meaning three times the width of the framelines. The problem does not

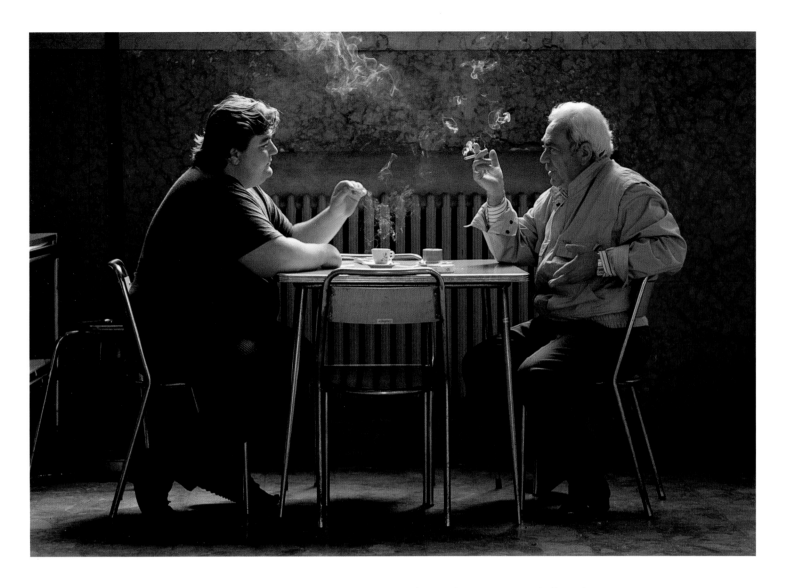

exist when using transparencies, since that area is more or less the same as the portion "stolen" by the mount. With negative film it must be kept in mind. In any case, the M6 has become enormously popular among photojournalists, who often take it along as an "extra" camera together with a reflex to take pictures under difficult conditions.

Like flashes of memory, the pictures on the following pages present scenes from the end of the twentieth century. The criteria that guided us through the earlier pages of this book are the same here: the protagonists are not historical events but human beings and their lives as they unfold. The basic truth of the Leica story is a moment of one human life captured forever by a camera held in the hands of another human being. For this reason it is not important that there is a picture of the war in Serbia but not one from the American campaign in Kuwait. A photo of war was needed, and we chose one of a mother fleeing Kosovo. The photo is valid for all mothers, for all wars.

Time as memory

This box is dedicated not to a professional photographer, but to a fortunate amateur, Enrichetta Bickel, who had the opportunity to travel around the world in the 1950s with a Leica M3. She had the foresight to preserve the images she took during those trips, such as this one of the Hiroshima memorial. Thanks to her efforts, her grandchildren can discover a distant world.

Passage to a new world

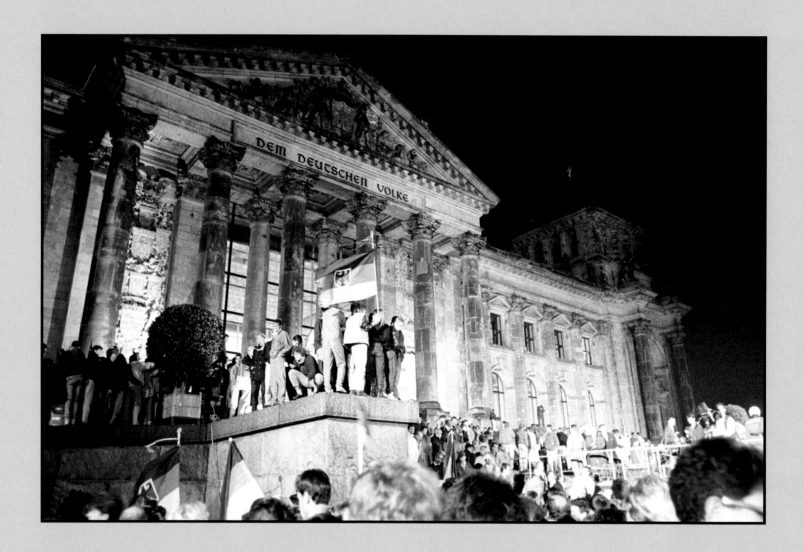

Stefan Thonesen, the fall of the wall of dishonor, the collapse of the Soviet Union

After the fall of the Berlin Wall, on November 9, 1989, the German Democratic Republic began to collapse. A crowd demanding the unification of the two Germanys gathered at the Brandenburg Gate (which divided the German city in two), and President Erich Honecker wanted to use armed force to disperse it. Instead he was forced to step down. (The photo is by Stefan Thonesen, among the leading Leica photographers of recent generations.) In the spring of 1990 monetary reform took effect, with the West German mark becoming the only currency. On October 3, 1990, forty-five years after the end of World War II, Germany was reunified. On December 31, 1992, the Soviet Union dissolved. In place of the Communist power there was now the CIS, the Commonwealth of Independent States, directed by Boris Yeltsin. And the old symbols, the red flag and statues of Lenin, went on sale in the streets of former Soviet cities.

Brandenburg Gate, Berlin, 1989.

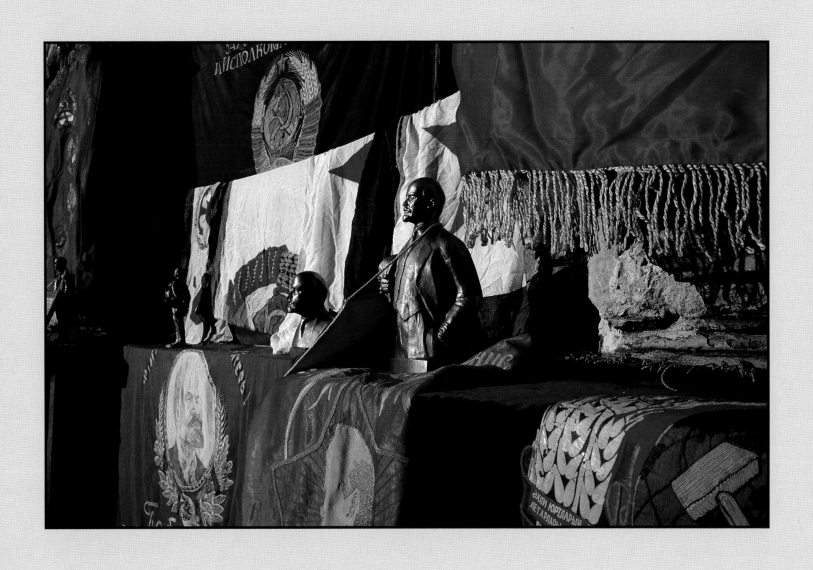

Alessandro Pasi,
Lenin on Arbat Street, Moscow, 1992.

Famine in Ethiopia, 1984.

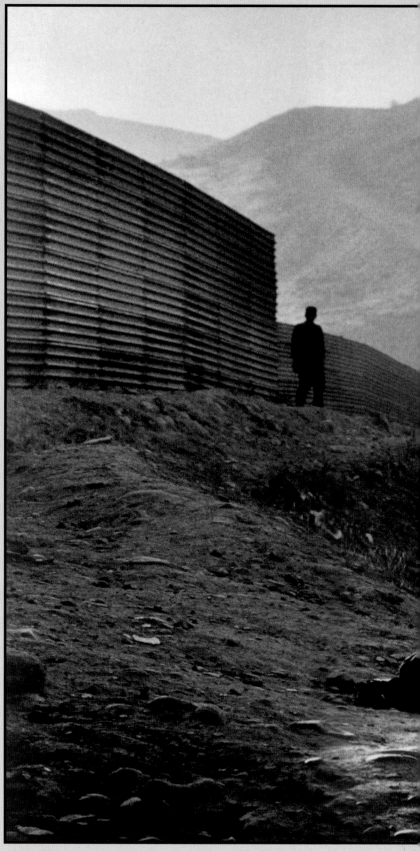

Tijuana, Mexico, Border with the USA, 1997.

Sebastião Salgado, or the new social journalism

Until 1970, when he was 26 years old, Salgado was an economist, involved with such international organizations as the World Bank. Then, as he himself has explained, something happened: "My wife was studying architecture, and one day she got a camera to use in her studies. I started using it too, and suddenly I discovered a new way of seeing life. Within a week I already had two new lenses. Then I managed to get a dark room. In a month photography had filled my life. . . . What I want is for my photographs to be the subject of discussion. I believe that photographers who get involved in social journalism are kind of like vectors that bring facts to the eyes of those who do not have the opportunity of seeing them directly."

140

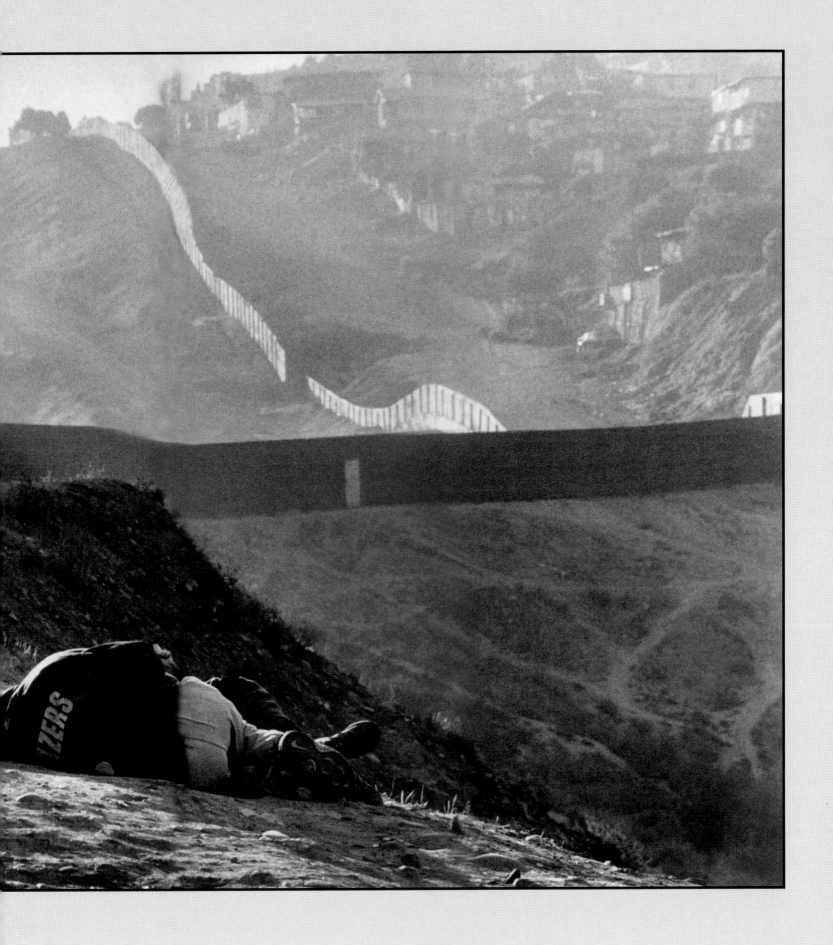

Luis Castañeda, dreaming of integration

Luis Cantañeda is a Cuban photographer, born in Havana in 1943. Like Salgado, he does not pose his subjects. As he says, he does not "make" photographs but rather "takes" them. The title of this picture is "The Black Swan," and it was captured in an elementary school in Miami, Florida, in 1990. The young girls were preparing for a dance recital, all of them showing varying degrees of nervousness as they waited for the beginning, including one particular girl, the Black Swan. For this image Castañeda used a Leica M6 with a Noctilux 50mm f/1 lens, the most luminous lens in the world.

The Black Swan, Miami, Florida, 1990.

Claus Bjørn Larsen, flight from Kosovo

War always means also exodus, with populations in flight from the victor of the moment. At the end of the 1990s, Kosovo was the scene of fierce fighting between Serbian militiamen and supporters of independence. The Danish photojournalist Claus Bjørn Larsen, born in 1963, was present at the beginning of the exodus and, Leica in hand, stayed close to the Albanian refugees. This picture, taken with a wide-angle lens, the new 24mm Elmarit, won him two prizes at the 2000 World Press Photo Competition.

Mary Ellen Mark, Mother Theresa

Born into a typical middle-class American family from Philadelphia,
Mary Ellen Mark began taking pictures in 1963, when she was 23.
She has reported from the USSR and India as well as the US. In 1984
she was awarded the Leica Medal of Excellence and in 1994 another
important recognition, the Dr. Erich Salomon Award. She says, "Social
reporting was a completely natural choice for me. I'm curious about
people, people who live in countries that are different from mine." In
1980 she photographed Mother Theresa in Calcutta while she caring for
a dying man in her hospital. The photo was taken with a Leica M4
using an Elmarit 28mm f/2.8.

146

Herlinde Koelbl, "Fine people"

This picture of well-to-to people at a party with their jeweled hands and painted fingernails that contrast so sharply with the bony, wrinkled hands of Mother Theresa, seemed an ideal way to point out that the legacy of the twentieth century includes enormous social differences that it is best not to forget. One critic called "Fine People" a razor cut with a Leica. It demonstrates the ability of Herlinde Koelbl (born in Lindau, Bavaria, in 1936) to look with a disenchanted eye on the world of high society. Koelbl had earlier distinguished herself for her male nudes and for two important works of photo journalism, one on Jews and the other on the German political class.

Andrea Battaglini, the forgotten East

In post-Ceauşescu Romania, an orthodox priest lights a candle in the church of a monastery that has been reconsecrated after the years of forced atheism. The picture is by Andrea Battaglini, born in Milan in 1957. He has a kind of personal photographic obsession with the countries of eastern Europe, moving from the palaces of Leningrad to the miseries of Romania, from the struggles of the Baltic states to free themselves economically to the folklore and country traditions of the Balkan countryside, which struggle to survive in the face of misery and forced westernization. Battaglini works exclusively with two Leicas, an M5 and an M6, and prefers wide-angle lenses, from 21mm to 35mm.

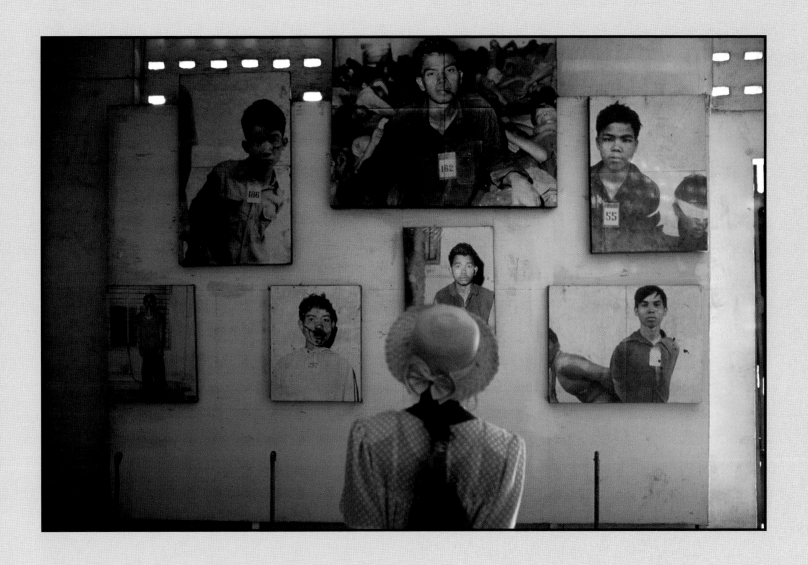

Alberto Bevilacqua, the victims of Pol Pot

In the center of Phnom Penh is Tuol Sleng, originally a school but transformed into a torture center by the Khmer Rouge police. Today it is a museum. The photos on the walls testify to the people who suffered and died in those sorrowful rooms. This image is from 1998, a dozen years after the fall of the bloody Pol Pot regime, and it was taken by Alberto Bevilacqua (from the Veneto region of Italy, born in 1961), using an M6 fitted with one of the most highly esteemed Leica lenses, the superluminous Noctilux 50mm f/1. Bevilacqua is particularly fond of that lens, not only because it permits him to take pictures in conditions of low light but also because of its delicate rendering of colors.

Fantozzi and Klein, the underground world

One of the great social processes that have flowed from the twentieth century into the new century is that of the globalization of markets and culture, in particular youth culture. These two pictures, one by Ernesto Fantozzi (left), the other by William Klein, are completely interchangeable: these kids on the subway, seated or dancing, could be in Milan or Paris. Or New York or London.

We have already met Fantozzi. Klein (born in New York in 1928), who received his first camera directly from the hands of Henri Cartier-Bresson, first came to attention because of his "crude" work on New York. He has his own unique way of working. He uses almost exclusively a wide-angle 28mm lens, and if he isn't happy with a scene he may provoke his subjects until he gets a reaction that justifies, in his eyes, the final "shot."

Leica M7
a touch of the automatic

Anyone expecting a revolutionary change from Leica in the face of the new millennium was disappointed.

By now it should be understood that Leica has its own concept of a revolution. What other camera makers had been providing for thirty years, such as automatic exposure setting or automatic focus (a convenience for the photographer, who chooses the diaphragm, and the light meter determines and sets the shutter speed), the German maker reserved for the new century. The M7, presented at the Photokina in Cologne at the end of 2002, is nothing other than an M6 with that touch of the automatic.

Unlike the M6, the speed and type of film loaded are visible in the viewfinder, thanks to the automatic DX setting.

To avoid offending purists enamored of mechanical cameras and determined to live without batteries, the M7 (despite its electronic shutter control) can take pictures at two emergency speeds, 1/60 and 1/25 of a second, and can be manually set up to a speed of 4 seconds (the M6, like all the M cameras, goes to 1 second) while in automatic it reaches 32 seconds. Production of the M6 was suspended, but its place was taken by the launching of a new, completely mechanical variant, the Leica MP, which has a kind of mechanical winder that attaches to the baseplate. This is the Leicavit rapid winder, invented during the 1930s, with a trigger in place of the original handle: it winds the film to increase the rate of shooting.

Shutter block

Another innovation: in front of the film-advance lever and shutter button is a knurled lever that serves the double functions of blocking the shutter button and interrupting the electrical feed to the light meter, thus shutting off the camera to save the batteries.

Shutter speed

For the first time on an M series camera, the speed-selector dial includes the letter A, for automatic.

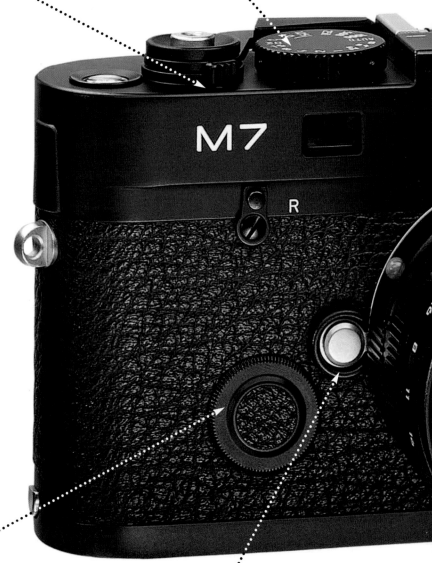

More electricity

Aside from powering the light meter, the batteries provide power to the new electronic shutter, a change from the M6.

Lens release

The system of attaching and detaching lenses has remained completely unchanged, and the M7 can use all the lenses of the M series.

More complete information

Aside from the diodes that indicate the correct exposure, the viewfinder of the M7 also gives information on the speed and the sensitivity of the film loaded. The system of focusing is still the rangefinder.

Three viewfinders to choose from

Beginning with the last series of the M6, the photographer has three types of viewfinder to choose from: the standard, with 0.72x enlargement (and framelines from 28 to 135mm), and two special ones for use with wide-angle or telephoto lenses, with enlargements of 0.85x and 0.58x (these lose, respectively, the framelines of the 135mm and the 28mm).

Return to origins: the O-Series

While photography moves increasingly toward the digital, Leica has taken a step against the trend. Here, for the collector of fully mechanical cameras and for the lover of manual photography, is a reissue of the Leica O-series, Barnack's second prototype, designed in 1914. The only difference is the focal-plane shutter, so it is no longer necessary to cover the lens with a cap between one photo and the next.

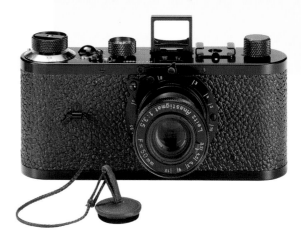

Improved lenses

Throughout the 1990s the optics in all the lenses in the M system were improved by the addition of aspherical lenses.

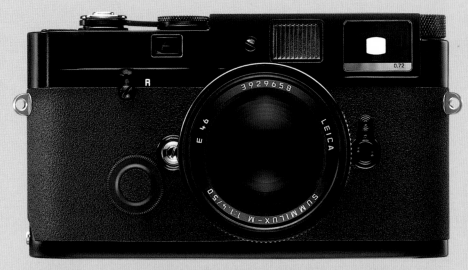

The new millennium: the enduring fascination of the mechanical

We made it to the year 2000 and immediately realized that nothing had ended on December 31, 1999, because centuries are made of calendars, but the epoch, the twentieth century, is not yet finished. To celebrate the goodbye to the last century and to emphasize this continuity we have chosen an image that connects to the past and the beginning of this book: the bridge and cathedral of Cologne on the night of December 31, 1999. The same bridge, the same cathedral, that Oskar Barnack photographed through the viewfinder of the first Leica. And beside it we present the most recent Leica, the MP, it too a bridge to the past: entirely mechanical and made to use two accessories created in the 1930s and reissued in 2000. The first is the Leicavit, a mechanical rapid film winder that attaches to the baseplate (in this version operational using one hand only: without taking the index finger off the shutter release, the trigger of the Leicavit is pulled with the bottom three fingers); the second is a rapid rewind that attaches to a button on the left of the camera. The Leica MP is available in chrome or black-lacquer finishes.

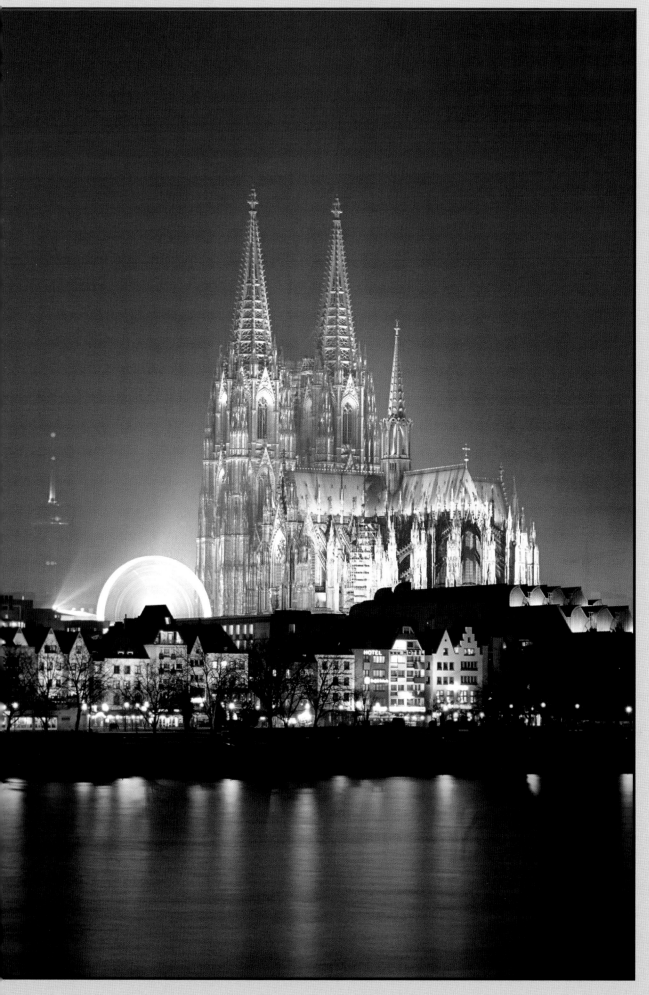

Today like yesterday

Left, the cathedral of Cologne illuminated for New Year's Eve, 1999, in a photo taken by Rolf Adam. Top, the same cathedral, from the beginning of this book, in one of the first photographs taken with the Ur-Leica by its inventor, Oskar Barnack (above).

The Leica family tree

LEICA MP

LEICA M7 2002

LEICA "0" Replica del 1923
2000

LEICA M6 TTL LACCATA
2000

LEICA M6 TTL 1998

LEICA EIN STÜCK 1996

LEICA M6 J 1994

LEICA M6 platino 1989

LEICA M6 titanio 1992

LEICA M6 1986

LEICA M6 1984

LEICA M6 Colombo 1992

LEICA M4-P 1983

LEICA M4-P 1980

LEICA M4-2 1979

LEICA MD-2 1978

LEICA M4-2 1977

LEICA CL 1973

LEICA M5 1971

LEICA M5 1971

LEICA MD a 1967

LEICA M4 MOT 1967

LEICA M4 1967

LEICA M4 1967

LEICA MD 1965

LEICA M1 1959

LEICA MP 2 1959

LEICA M2 1958

LEICA M2 1958

LEICA MP 1956

LEICA M3 1963

LEICA M3 1956

LEICA M3 1954

LEICA I f 1952

LEICA I f 1952

LEICA II f 1952

LEICA II f 1951

LEICA III f 1950

LEICA I c 1949

LEICA II c 1948

LEICA III c 1940

LEICA 250
Reporter (III a) 1934

LEICA 250
Reporter (III) 1933

LEICA III 1933

LEICA III 1933

LEICA II 1932

LEICA Standard 1933

LEICA Standard 1932

LEICA I
„O"-Abstimmung 1931

LEICA I
Schraubgewinde 1930

LEICA I
Anastigmat 1:3,5 1925

PROTOTIPO 1 1923

UR-LEICA 1913/14

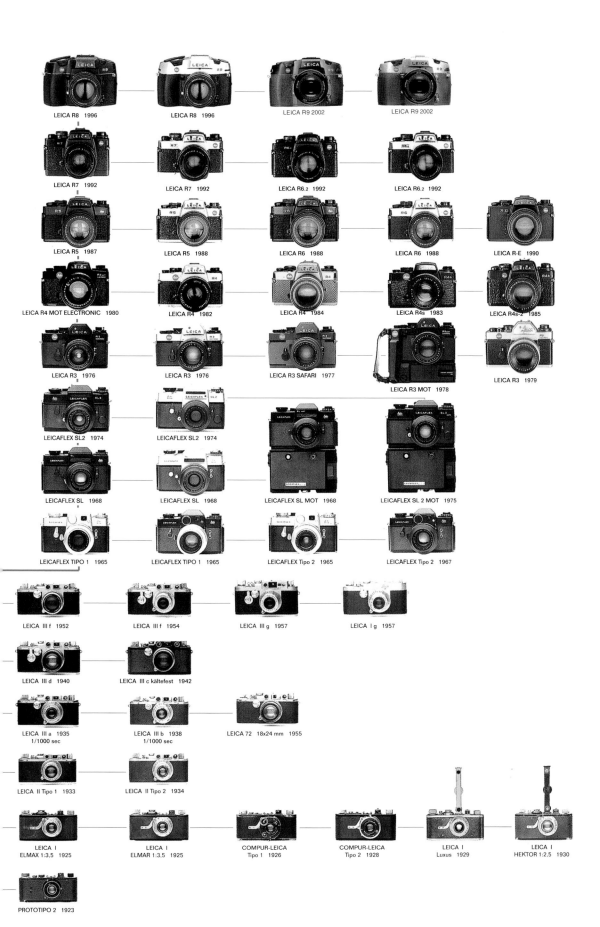

LEICA R8 1996

LEICA R8 1996

LEICA R9 2002

LEICA R9 2002

LEICA R7 1992

LEICA R7 1992

LEICA R6.2 1992

LEICA R6.2 1992

LEICA R5 1987

LEICA R5 1988

LEICA R6 1988

LEICA R6 1988

LEICA R-E 1990

LEICA R4 MOT ELECTRONIC 1980

LEICA R4 1982

LEICA R4 1984

LEICA R4s 1983

LEICA R4s-2 1985

LEICA R3 1976

LEICA R3 1976

LEICA R3 SAFARI 1977

LEICA R3 1979

LEICA R3 MOT 1978

LEICAFLEX SL2 1974

LEICAFLEX SL2 1974

LEICAFLEX SL 1968

LEICAFLEX SL 1968

LEICAFLEX SL MOT 1968

LEICAFLEX SL 2 MOT 1975

LEICAFLEX TIPO 1 1965

LEICAFLEX TIPO 1 1965

LEICAFLEX Tipo 2 1965

LEICAFLEX Tipo 2 1967

LEICA III f 1952

LEICA III f 1954

LEICA III g 1957

LEICA I g 1957

LEICA III d 1940

LEICA III c kältefest 1942

LEICA III a 1935
1/1000 sec

LEICA III b 1938
1/1000 sec

LEICA 72 18x24 mm 1955

LEICA II Tipo 1 1933

LEICA II Tipo 2 1934

LEICA I
ELMAX 1:3,5 1925

LEICA I
ELMAR 1:3,5 1925

COMPUR-LEICA
Tipo 1 1926

COMPUR-LEICA
Tipo 2 1928

LEICA I
Luxus 1929

LEICA I
HEKTOR 1:2,5 1930

PROTOTIPO 2 1923

157

Index of names

Photo credits

Rolf Adam archive	p.	155
Andrea Battaglini archive	p.	148
Gianni Berengo Gardin archive	pp.	114, 115, 116, 117
Alberto Bevilacqua archive	p.	149
Piergiorgio Branzi archive	pp.	96, 96-97
Vanni Calanca archive	p.	137
Luis Cantañeda archive	pp.	142-143
Mario De Biasi archive	pp.	94, 94-95, 130-131
Ernesto Fantozzi archive	pp.	104, 105, 150
William Klein archive	p.	151
Herlinde Koelbl archive	p.	147
Klaus Bjørn Larsen archive	pp.	144-145
Mary Ellen Mark archive	p.	146
Susan Maroon archive	p.	126
Jim Marshall archive	pp.	124-125
Luftschiffbau Zeppelin archive Gmbh, Friedrichshafen	pp.	44 above, 45
Leni Riefenstahl archive	pp.	60, 61, 132, 133
Stefan Thonesen archive	p.	138
Magnum Photo/Contrasto, Milan	pp.	56-57, 68, 69, 82, 90-91, 92-93, 102-103, 118-119, 120, 121, 140, 140-141
Grazia Neri Agency, Milan	pp.	63, 98-99
Laura Ronchi Agency, Milan	pp.	83, 78-79
Agenzia SIAE, sec. OLAF, Rome	pp.	52-53
Zefa Visual Media Italia Agency, Milan	p.	37
Photographique, Paris	pp.	54-55
Photo De Bellis	p.	44 below

Unless otherwise indicated, the photos are from the archives of Polyphoto-Leica and the author.

The editor regrets any errors in this list and will endeavor to correct any brought to light.

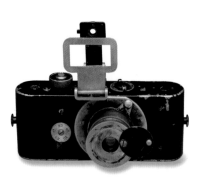